The Myth and Magic of
Nemadji "Indian" Pottery
History, Identification and Value Guide

by

Michelle D. Lee

The Myth and Magic of
Nemadji "Indian" Pottery
History, Identification and Value Guide

WRITTEN BY
 Michelle D. Lee

GRAPHICS DESIGNER/DESKTOP PUBLISHER
 Beth Travis-Betts, *Art Direction and Advertising, Duluth, MN*

PHOTOGRAPHY
 H. Brian Rauvola *Photographic Studios Two Harbors, Minnesota*
 Scott Nielsen, *Superior, WI – cover photo*

First Edition
Published by
 Left Hand Publishing Company, Moose Lake, Minnesota
ISBN 0-9744799-0-X
Library of Congress: 2003096785

Printed in the U.S.A.

The Myth and Magic of
Nemadji "Indian" Pottery
History, Identification and Value Guide

by

Michelle D. Lee

published by

Left Hand Publishing Company
Moose, Lake, MN 55767

© 2004

Note from the author

The prices quoted in *The Myth and Magic of Nemadji "Indian" Pottery; History, Identification and Value Guide* are just that, a guide.

As with most collectibles, prices for Nemadji pottery will vary from region to region. Price may also depend on the venue where it is sold. One might pay one price at an auction, another at an antique store ... and quite another price at a garage or tag sale.

As with all collectibles, condition, supply and demand will set the price.

Neither the author nor the publisher assumes responsibility for any loss that might occur as a result of consulting this book.

Questions and suggestions may be mailed to the following address:

Left Hand Publishing Company
PO Box 253
Moose Lake, MN 55767

 # Nemadji "Indian" Pottery
Contents

Dedication

Preface

Acknowledgements

*This book is dedicated to my
mother, Betty Jane Devlin, and my
late mother-in-law, Lillian Kovanen.*

Preface

The book, *The Myth and Magic of Nemadji "Indian" Pottery; History, Identification and Value Guide*, grew out of a passion for collecting a Minnesota-made pottery.

The first piece of Nemadji found its way into my home in 1983, the year I moved to Moose Lake, Minnesota. I stumbled across the pot in the bottom of a cardboard box at a Saturday morning garage sale. It was made of red clay and had a rainbow of earthen colors splashed around it.

On a whim, I picked up the little pot and carried it, along with a pair of cross-stitched dresser scarves to the checkout line. Waiting in line to pay for my treasures, I took a closer look at the pot. Turning it in my hand I began to wonder about its interesting coloring. It had a sliver of black running along a meandering ribbon of robin's egg blue. A touch of yellow and a dab of red paint had been artfully swirled alongside them. On the bottom of the little red clay pot was a stamp mark, made in black ink. It read, "Hand Made Nemadji Indian Pottery (From Native Clay)."

I wondered if this little pot had indeed been made by Indians. What a find that would be, I thought. The more I examined it, the more questions I had. When had it been made? To what tribe of Indians did it belong? How did the potter manage to paint the swirls so perfectly? After a minute or two I shook my head in disbelief. Had this little treasure somehow cast a spell upon me? I wondered. There I was, about to buy something that didn't even have a price tag on it. When it was my turn to pay for my purchases I asked the seller what she knew about the pot.

"Oh that?" she asked. *"That's a piece of that Nemadji crap."*

"Nemadji," I slowly repeated.

"Yah," she replied. *"They used to make it around here."*

"How much?" I asked, holding my breath.

"Give me a dime."

The woman's effort to defame the little red pot failed and my discovery sparked the start of a long love affair with Nemadji Pottery. It also sparked a lengthy and continuing effort to unearth every nugget of information I can find about this mystery pottery. Those nuggets have been put together for you in *The Myth and Magic of Nemadji "Indian" Pottery; History, Identification and Value Guide*.

I'm calling this a first edition because I have learned there is always one more thing to learn about Nemadji Pottery. I have no doubt "that one more thing" will be included in a second edition.

Acknowledgements

M any have helped in my quest to learn the history of Nemadji pottery, as well as its connection to Garden of the Gods Pottery.

Carol Carlton, the author of the seminal book on western pottery, *"The Collectors Encyclopedia of Colorado Pottery; Identification and Values,"* published in 1994, was extremely patient with me as I sought her aid in gathering information about Eric Hellman and his Garden of the Gods Pottery.

In Moose Lake, Minnesota, I thank Stanford Dodge and his sister Morieta (Dodge) Larson, Kenneth Kasden and his brother, Bruce, and Helen Keith and her husband Francis for sharing their personal experiences as past and present owners and former employees of the Nemadji Operation.

Harold Wahlstrom and his wife, Dorothy, along with Dorothy's brothers Gerin and Russ Bogenholm, also provided wonderful stories and many details of their years with the tile and pottery in Moose Lake. Their information was crucial in putting together many of the pieces of this fascinating puzzle.

Jerry DeRungs of the *Moose Lake Star Gazette,* Lois Johnson at the *Arrowhead Leader* in Moose Lake and the late Joe D'Antoni and Howard Ballou graciously provided historical documentation and personal accounts.

Other equally important sources of information include Cliff Letty, Frances (Johnson) Berquist and her son, Lloyd Berquist, collectors Eric Cederberg and Joyce Hultberg and the late Skip Hanson.

Appreciation also goes to Donna McCrea, the special collections librarian with Penrose Library in Colorado Springs, Colorado.

I would also like to thank Nancy and Bob Hanson of the Moose Lake Area Historical Society (MLAHS) for their encouragement and their patience in locating photographs and proofreading my manuscript, over and over again.

My husband, Gary Kovanen, and our son, Fred, were guiding lights in this project. Gary kept me focused until the final word was written. Fred added humor and an eagle's eye for spotting Nemadji in the most unlikely places. Even at the early age of four, our son was the first to spot the pots when we went 'tiquing. Thank you both for your time and patience.

Myth-Understandings

Several years ago, Mr. and Mrs. Stanford Dodge of Moose Lake, Minnesota traveled out west. Their vacation took them to Arizona. In downtown Phoenix they visited a fine old hotel.

In the grand lobby of this hotel they stopped to admire a beautiful display of pottery. The professional display represented the traditional art of several Native American tribes. The pottery offered rich colors, primitive shapes and printed placards describing their origin.

One of the smaller pots caught Stanford's eye. Its red clay was reminiscent of the clay found near his Minnesota home. The bright swirls of primary-colored paint picked up the colors of the earth and sky. The card placed next to the pot read, "Made by the Nemadji Indians of Minnesota."

Stanford motioned to a young woman working behind the hotel's front desk and called her over to the display.

"I know where this pottery really came from," he told her.

"Yes," she said. "It was made by ancient Indians from the Minnesota region."

"No it wasn't," he replied. "Your information is only half correct. That pot was made in Minnesota, but not by Indians."

"Where did you get your information?" the young woman asked in a low voice.

"My father started the factory that made this pottery ... I worked there as a youngster," he whispered back.

"You couldn't have, Sir. You are not ancient, and you are certainly not an Indian."

The former Mayor of Moose Lake, Bruce Kasden, tells this story:

"I was out in Arizona. This was a few years ago. As I traveled along the interstate, I spotted a sign. It read, Nemadji Pottery five miles ahead. Knowing a little about the history of the pottery, I decided to have a look. So, I pulled off the highway and stopped at the small curio shop.

"Inside they were selling a variety of items for tourists, including Nemadji Pottery. Nodding in the direction of the pottery display, I asked the proprietor, 'Do you have any idea where this came from?'

"'Yes I do', she said. 'We have an Indian who makes it right here.' Well, my interest was piqued.

"'Where?' I asked.

"'Right in back,' she said. 'Come, I'll show you.'

"I followed the woman through her shop to the back door. We went outside and there, not far from the shop stood a teepee. Sitting in front of it was an elderly Indian man.

"'He makes it right in there', she said, pointing to the Teepee."

Did Bruce set the record straight?

Offering Nemadji as Indian made is a mistake made by many, including Better Homes and Gardens magazine.

"I'm not going to destroy a good story like that," he explained. *"That story is wonderful."*

Offering Nemadji as Indian made is a mistake made by many, including *Better Homes and Gardens* magazine. In its Remodeling Ideas 1982 Spring Edition, the Moose Lake tile was mentioned in an article entitled, *"Dine in an Oriental Tea Room."*

"Capturing the serenity of contemporary Japanese design was the objective of James and Mary Schwebel's remodeling plans," the article noted. The article went on to describe the new flooring in the Schwebel's living room…'The rich earthen hues of the N2madji <spelling> floor tile, made by the AMERICAN INDIANS (emphasis added) at Moose Lake, Minnesota, pave the living room and the new dining platform."

The Internet has also been fertile ground to expand and propagate the *Nemadji Myth*. The ebay® auction site has been a good resource for collectors seeking the more unusual pieces of Nemadji Pottery. Sellers have also used some creative writing to promote their lots.

"This lovely hand-painted, hand-made Nemadji American Indian vase is decorated in perfectly harmonized shades of rose to magenta, with accents of black and gray on a background of unglazed beige pottery," one seller noted, adding "The Nemadji Pottery crafters are masters indeed of harmony in color and graceful design. This would be a glowing addition indeed for any serious NATIVE AMERICAN (emphasis added) collection."

These are among the many "Myth-understandings" associated with the sale and collection of Nemadji Pottery. As you'll learn in the coming chapters these myths were carefully crafted and cultivated from the very first day the swirl-painted pottery was produced at Moose Lake, the gateway to Minnesota's Arrowhead Region. 🦌

The Arrowhead

The word, *Nemadji* comes from the language of the Anishinaabe or Ojibwe people of Minnesota's Arrowhead Region. Contrary to what some believe, Nemadji is not the name of a clan of ancient Indians who once lived in Minnesota nor is it the name of the "tribe" that made the swirl-painted tourist pottery. Roughly translated the word means *"left hand."*

In 1899, a University of Minnesota professor set out to name the 29 glacial lakes and rivers in the Lake Superior Arrowhead Region. The region encompasses the upper right hand corner of the state which resembles the shape of an arrowhead.

While charting the red river which empties into Lake Superior between Minnesota and Wisconsin points, the professor asked members of the local band of Ojibwe what name they used.

"Nemadji," (nah-MAD'-gee) they replied.

The river was the first on the left, as the native fishermen made their way from the big lake to the St. Louis River.

The Nemadji River travels across the ancient clay beds of Northeastern Minnesota and Northwestern Wisconsin. At its mouth, the river spews red plumes of sediment into the crystal clear waters of Lake Superior. These plumes create 50 percent of the sediment deposited at Duluth-Superior.

The clay beds were created by retreating glaciers. As the massive glaciers moved, they ground tons of rock into fine powder which settled on the bottom of an ancient lake.

A stone monument displayed near the outlet of Moose Head Lake in Moose Lake described the process which created the area's unique topography:

"Towards the end of the great ice age, about 10,000 years ago, the glacier which pushed its way along the trough of Lake Superior retreated toward the northwest and near Moose Lake crossed the divide between the Mississippi River and Lake Superior.

"When the lobe of ice was shrunken so that it lay wholly within the rim of the lake basin, glacial Lake Nemadji was formed around the southeast margin of the ice. The earlier outlet was at the western end, when the lake stood 523 feet above the present level of Lake Superior and nearly reached the level of the state hospital."

In his book, *Moose Lake Area History,* the late David E. Anderson recalled how local children in the 1920-30s used to gather snails, clam shells and sea shells on the Soo Hill, in Moose Lake.

Thousands of years ago, the area was also home to the Mound Builders. Near Sturgeon Lake, a half

The Nemadji River travels across the ancient clay beds of Northeastern Minnesota and Northwestern Wisconsin.

dozen or more of their mounds have been located over the years. Students of anthropology believe ancestors of the Dakota Indian tribes who lived here prior to the arrival of the Ojibwe built them for burial purposes.

It's believed the mounds themselves were constructed between 500 B.C. and 1700 A.D.

The City of Moose Lake was established near a stagecoach stop around the time of the Civil War, shortly after the Military Road was built between St. Paul, Minnesota, and Superior, Wisconsin. In 1870, The Lake Superior and Mississippi Railroad established a line that traveled within three miles of town, fueling the city's growth.

As a result of earlier treaties with the U.S. government, many of the area's Ojibwe had already been moved onto the Mille Lacs and Fond du Lac reservations.

When northern European immigrants settled in the area to harvest timber and build their farms, they found the passing seasons still brought the Ojibwe to hunt, fish, harvest wild rice and tap the local sugar bush for syrup production in lands ceded to the government.

The Finns and Swedes had difficulty conversing with these Native Americans, but they did manage to coexist and trade a variety of goods.

Local history tells of a colorful meeting between the matriarch of one of the earliest white families to settle here and an Ojibwe man passing through on his way to hunt. The man walked into the home and began picking up pieces of food and articles of clothing. Unable to understand the man's attempts to trade, the elderly woman took her broom in hand and drove the stranger out of her house.

John Smith of Cass Lake was one of the area's celebrated Native Americans. Written accounts claim he lived to the age of 137 and was a frequent visitor to Moose Lake, where he would trade with area farmers. Smith had a free pass with the Soo Line Railroad. He reportedly slept on the baggage car floor on his own blanket. 🫎

The Great Fire of 1918

One of the most horrific events ever to occur in the state happened in Northeastern Minnesota in 1918, when a summer long drought pushed the fire danger to extreme levels.

That fall, sparks thrown by passing trains ignited several small fires that grew into one massive wall of flames.

Once the fires joined, the resulting inferno danced quickly from the tops of towering white pines down to the small towns they sheltered. The heat created by the burning of millions of board feet of timber was so great that the fire created its own wind as it moved across Pine and Carlton Counties.

The flames then traveled northeast to the shores of Lake Superior, north of Duluth. Along the way 10 towns were destroyed and many others sustained extensive damage.

Moose Lake and Kettle River were rebuilt. Splitrock and the Finnish settlement of Automba were among those that were not.

Property losses exceeded

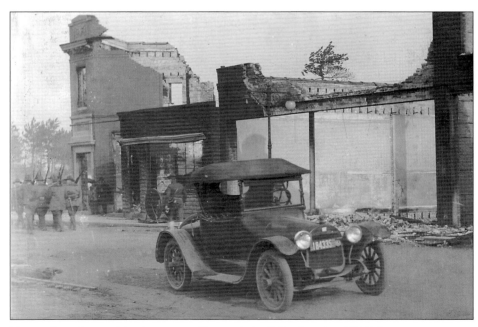

Home Guard patrol in downtown Moose Lake following the 1918 fire.
— COURTESY OF MLAHS (MOOSE LAKE AREA HISTORICAL SOCIETY)

*Among the first enterprises
to rise was The Northern Clay
Products Corporation
in Nemadji Township,
northeast of Moose Lake.*

$28-million dollars. As dramatic as the loss was in 1918 dollars, the death toll was unimaginable: 453 lives were lost in the Moose Lake and Cloquet areas.

Some of the more tragic accounts involved families who took refuge in their root cellars. The cellars protected them from the flames, but the fire consumed their oxygen causing them to suffocate.

Those who were unable to reach their wells or root cellars survived the fire by lying down in freshly plowed farm fields and covering themselves with wet blankets. Others jumped into Moose Head Lake until the firestorm had passed.

When word of the conflagration hit Minnesota's capitol city of St. Paul, the governor called up the state's Home Guard to bury the dead and maintain order among the survivors.

Red Cross volunteers built "fire shacks" to house victims during the coming winter. These were hastily built, one-or two-room wooden shelters. There was no insulation and the only heat source was a small, wood-burning stove.

When the snow and cold hit, so did the world-wide influenza epidemic of 1918, claiming even more lives. How bleak it must have been for those who were lucky to be alive. Their forest industry had been decimated, farms burned to the ground, fall harvests and future seed destroyed, and the region's dairy herd claimed by the fire.

Surveying the carnage after the spring snowmelt many doubted the area would ever rise from the ashes. But others refused to give up, and vowed to rebuild.

Among the first enterprises to rise was The Northern Clay Products Corporation in Nemadji Township, northeast of Moose Lake.

Nemadji Township

Nemadji Township is located on a large bed of clay, northeast of Moose Lake, Minnesota. The township was developed by the Soo Line Railroad in 1909-10, as a rail stop to take on white pine logs and the U.S. Mail. (The last bag of mail was shipped from Nemadji in 1953. A commemorative sign posted along Carlton County Road 11 is all that remains today.)

Ceramist Frank Johnson was drawn to Nemadji Township just before the Great Fire of 1918.

Johnson was born during the Civil War on a farm in Minnesota's Goodhue County. The son of Swedish immigrants, he embraced all things American and when he was old enough he eagerly struck out on his own.

When he did, he married Dehlia Skoglund, a member of his church choir, and they settled in the Mississippi river town of Red Wing, where Johnson worked as a ceramist.

The town's first large pottery operation, the Red Wing Stoneware Company, was established in 1878.

The ensuing years recorded a major fire at the plant and brought tough competition from the Minnesota Stoneware and North Star Stoneware companies.

In the late 1800s, all three consolidated.

Ultimately this consolidation

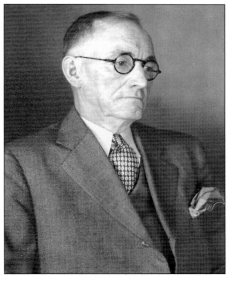

Frank Johnson, founder Northern Clay Products Corporation.
— COURTESY OF LLOYD BERQUIST

resulted in a merger and the creation in 1906 of the "Red Wing Union Stoneware Company."

When he wasn't busy creating salt glaze crocks, jugs and bowls for Union Stoneware, Frank Johnson was experimenting with clay. According to his daughter, he set up a small kiln next to the horse stable in their backyard. There he fired pottery for his wife and experimented with clay mixtures.

Frances (Johnson) Berquist remembered her father's pottery, especially the pieces made during

Following the great fire, the demand for fire-proof building material exploded. By 1920, The Northern Clay Products Corporation focused much of its efforts on brick making.

her childhood in Red Wing:

"Father threw pots and dishes on his wheel. I never kept any for myself. He also taught me how to make doll dishes. Oh, how I wish I still had those little dishes."

Johnson stayed on at the stoneware plant for a steady paycheck to support his growing family. Those who knew him said his efforts in his backyard nurtured his creative soul.

His ultimate goal was to create a business where he could care for both.

Johnson's talents were not lost on his supervisors at Union Stoneware and by 1910 he joined their ranks as a supervisor.

By 1912, Dehlia and Frank had four children and life in the idyllic river town was good.

When Dehlia fell ill and died in 1914, Johnson was devastated. Frances said he became withdrawn and quit his job at the plant, taking on odd jobs to feed the family. Even though deep in grief, Johnson never lost hope of owning his own business.

When he learned about the clay beds in northeastern Minnesota, he headed north. Daughters Frances and Marie were left behind with their oldest sister Lucille in LeSeur, Minnesota until he could earn enough money to fetch them.

Son Donald moved on with Johnson to Nemadji Township, the site of an earlier brick-making operating.

Within months of their arrival father and son constructed a small hand hewn log cabin and set up a kiln to fire pottery and bricks for the locals.

Following the Great Fire, the demand for their fire-proof building material exploded.

By 1920, the newly incorporated Northern Clay Products Corporation focused much of its efforts on brick making. Nemadji clay produced adequate brick, but the clay beds found to the north near Wrenshall produced a superior product.

According to the Carlton County Historical Society's book, *"Reflections of Our Past: A Pictorial History of Carlton County Minnesota,"* Fred J. Habhegger opened the first brick plant in Wrenshall in 1898. He and two of his local competitors produced an estimated 600 million bricks, providing the building materials for many buildings in northeastern Minnesota.

Nemadji brick was used in the construction of a creamery and a bank which still stand in the city of Barnum, five miles north of Moose Lake.

Unfortunately, no known examples of Johnson's early "Nemadji clay" pottery remain, but they are remembered.

The late Howard Ballou's father was the telegraph operator for the Soo Line in Nemadji. As a youngster

Howard went to an open house at Johnson's plant.

"He had a round table about the size of a small tub. It was geared up to a foot pedal underneath so when he worked the pedal with his foot, the table turned round and around. On the center of this table he put a chunk of well-mixed clay. As the table turned, Johnson used his hands to form a gallon jug. He put a handle on it and it looked neat. Then he made vases of different shapes and sizes. They and the brick had to be fired on the spot in a large kiln."

He also recalled how Johnson fashioned small vases for the ladies during the open house.

Johnson's open house in Nemadji attracted enough business to allow him to retrieve his young daughters and bring them north. His cabin was so primitive, however, Frances said, he refused to allow the girls to live there. Instead they lived with a family in nearby Barnum, to whom Johnson paid room and board. With his family close by, he continued to experiment with the local clay.

"He knew where most of the clay beds were hidden in Minnesota," Frances said. *"He loved to use the wheel and make pottery. And ... he knew instinctively how the clay would react in the kiln."*

When the Northern Clay Products Company was incorporated, Johnson was listed as the secretary of the corporation. John Seimer held the position of treasurer and Frank Ebert was president.

Ebert left the business soon after the company's articles of incorporation were filed with Minnesota's Secretary of State. In need of capital, Johnson turned to a Moose Lake businessman named Clayton James Dodge.

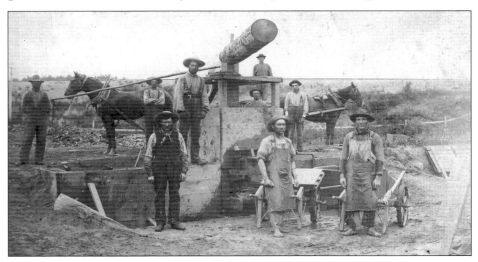

Brick manufacturing near Nemadji, circa 1890s.
— COURTESY OF MLAHS

Forging the Future

Clayton James Dodge, also known as C.J., was born in southern Minnesota near Dodge Center. Dodge attended the Pittsburgh Academy at Owatonna and went on to the State University to earn his teaching degree.

He taught school in southern Minnesota, but within two years a new ambition reared its head and Dodge returned to school to study law. School completed and bar passed, the young man was anxious to start practicing what he had learned.

The first step in his legal career took him to Aitkin, Minnesota, where he opened an office. Within six months he moved again, after he heard Moose Lake needed a lawyer. In 1901, he packed his meager belongings and set out by foot across a vast white pine forest to that community, over 40 miles distant. No maintained roads existed at that time to connect the towns. Dodge later told his son, Stanford, that halfway to his new home he spent the night in an abandoned logging shack.

The book, "*Moose Lake Area History*," describes how the locals didn't give Dodge much hope for success. After meeting with the village council, Mayor Nels Berquist remarked, "I think I would rather be an old carpenter than a lawyer in this town."

Nonplussed, Dodge established his office in a back room of the Moose Lake State Bank.

In 1907, he was elected to serve as Carlton County Attorney. A year later Dodge built the first home located on the lakeshore. The first story of his house was built of concrete blocks with stucco on the outside. The second floor was a frame structure. By all accounts, it

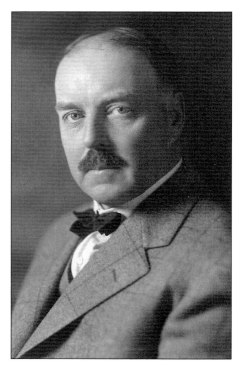

Clayton J. Dodge, founder Nemadji Tile and Pottery Company.

— COURTESY OF JAMES DODGE

was the finest home in town.

Dodge's arrival in Moose Lake coincided with the harvest of the white pine forest that once covered much of northeastern Minnesota. The elder Dodge supplemented his law practice by buying and selling logs.

"Ingenious," Stanford said of his father.

During his first year in Moose Lake, he made more money in the timber business than standing before a judge. And there was money to make for those who had ambition. Just before the turn of the century, an estimated 10 million feet of timber was taken in the Mud Creek area near Moose Lake. Most of it made the 30-day trip down the Kettle and St. Croix rivers to Stillwater.

At Stillwater, the logs were sawn and the newly cut lumber was shipped to cities like Chicago and St. Louis, where it was used to build housing during the western expansion.

Second only to lumbering of the local white pines was the cordwood and railroad tie production near Moose Lake. Ties were often piled for a half-mile along both sides of the Soo Line Railroad tracks within the city limits. White pine logs were stacked stories high along Main Street, awaiting rail transport.

Following the Great Fire in 1918, Dodge went to court on

At times it must have seemed the whole country was under construction. Looking for a local investment that could ride this expansionist crest, Dodge joined forces with Johnson and brought much-needed capital to The Northern Clay Products Corporation.

behalf of the victims and their families to file legal claims against the railroad. The settlements from those claims were used to rebuild the Northland and secure Dodge's financial future. That wouldn't happen, however, until the 1930s. In the meantime, he continued to seek opportunities and investments.

In 1922, homes and businesses continued to rise from the ashes left by the Great Fire. The demand for building materials wasn't limited to his home state.

It was the Roaring '20s and the western expansion continued at a rapid rate. At times it must have seemed the whole country was under construction. Looking for a local investment that could ride this expansionist crest, Dodge joined forces with Johnson and brought much-needed capital to The Northern Clay Products Corporation.

Nemadji Tile and Pottery Company

The Dodge-Johnson partnership brought big changes to the small brick-making business in Nemadji. Resigned to the fact that they would never wrestle away the top spot from Wrenshall Brick Company, they set out to carve their own niche by focusing exclusively on tile and pottery.

With this new focus came a new name and new location.

The Nemadji Tile and Pottery Company plant opened for business on the Soo Hill in Moose Lake in 1923.

The hill was named for the Soo Line railroad tracks that cut across the west side of town. The plant was tucked back in the woods, along the railroad tracks near what is now the Depot and Fires of 1918 Museum.

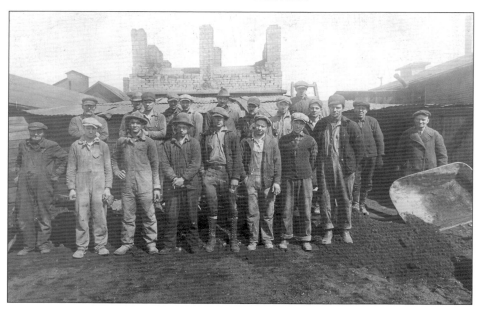

Nemadji Tile and Pottery Company, Moose Lake, MN circa 1925. These are the names inscribed on back of this photo: John Ehr, Claud Couillard, Herb Anderson, Bertil Bogenholm, Sooner Harmon, Harold Carlson, Ted Anderson, Ray Skelton, Mr. Harmon, Ed Staberg, Frosty Skelton, Stan Bogenholm, Walt Bogenholm, Claude Anderson, Ed Losenski, Leon Peterson, Bogenholm, Lawrence Harmon, Ben Siemer.
— COURTESY OF MLAHS

Resigned to the fact that they would never wrestle the top spot from Wrenshall Brick Company, they set out to carve their own niche by focusing exclusively on tile and pottery.

Nemadji Tile

The first kilns were small affairs used to produce plain and decorative tile using the area's colorful clays. The decorative tile had etched designs in the shapes of flowers, birds and animals.

Later, two massive beehive kilns were constructed to fire the expanding line of tile and pottery. The new kilns were approximately 12 feet in diameter and were fired by coal, brought in by rail.

The larger of the two kilns contained 3,000 square feet of usable space, while the smaller had about 2,500 square feet.

Buildings were also constructed for cooling and shipping operations.

The clay used for the tile was mined just east of Moose Lake. According to the late Howard Ballou, it still came from Nemadji.

"Oscar Peterson, Charles Schwoch and N.B. Nelson would hitch up their teams to the wagons. They also loaded up their boys and dug the clay by hand. When the wagons were full, the horses would pull them back to Nemadji.

The men would shovel the clay into gondola railroad cars sidetracked there," he said in an interview shortly before his death.

This early effort must have been massive.

"They made such a hole in the earth," Ballou recalled. *"It eventually filled with water and my boys and Ralph Henninger's boys swam in it in the summer and skated on the ice in the winter."*

Brothers Don and Bob Carlson harvested Nemadji clay just after WWII. Don recalled filling Bob's dump truck with the clay and delivering it to the plant on Soo Hill. The door to the clay shed was too low and it prevented them from using the hydraulic dump on the truck.

"We had to unload the clay by hand, using shovels," Don said.

That back-breaking day of work was pivotal in both man's careers. Shortly after, Don signed on with an ore boat plying the Great Lakes far from Nemadji. Bob continued in the trucking business hauling anything but heavy, wet clay.

In the early days the gray clay for the light colored tile was mined near Wrenshall, from the same clay pits used to make Wrenshall Brick. This clay fired a creamy buff color, with a touch of either pink or light yellow and produced a durable brick.

Many buildings constructed with Wrenshall brick remain in the small town southeast of Duluth, including

Within months of opening their doors, Dodge and Johnson were shipping their tile products by rail nationwide.

the Brickyard Restaurant and Coffee Shop.

While Wrenshall was claiming the prize for best regional brick, Nemadji Tile and Pottery was earning a national reputation for its floor tile. Few producers could compete with the beauty and durability of the Moose Lake tile.

Nemadji tile came in all sizes and shapes: 1-by-1 inch, 1-by-2 inch, 3-by-8 inch. From rectangles to hexagons, from wainscoting to floor molding, the earth-shaded tile caught the fancy of the wealthy.

Within months of opening their doors, Dodge and Johnson were shipping their tile products by rail nationwide.

During the 1920s the kilns worked overtime to meet demand. Nearly 30 local men found steady jobs mixing clays, working at the tile forms and feeding coal into the kilns. During the Great Depression, C.J. Dodge himself fed the fires.

The same creative process used early on to make Nemadji tile was repeated over and over again, for nearly 50 years.

"When the small colored tiles cooled," explained Stanford, *"we had to put them together like a puzzle and glue paper to the back to hold them in place. That made it much easier for the tile setters."*

Russell Bogenholm remembered getting paid two cents a sheet to do this tile "paper" work.

"The dry clay and coloring was put into a 'pug mill'," recalled Russell's brother-in-law, Harold "Wally" Wahlstrom.

"The mill would turn dry clay into chunks of colored clay. It was a great big wheel that squashed the clay and formed chunks of clay," he added.

"Those chunks were moved by a system of belts to an extruder. The extruder was like a big old-fashioned meat grinder. The clay chunks went into the top, and it ground it up and pushed it through the exit. The exit had bolted on nozzles that would determine the design."

Using various styles of nozzles, workers extruded blocks or flat sheets of clay. A guitar string was used to cut the clay. After it was cut, it was put on pallets and moved over to a press.

"At first we had to pull a lever to stamp the clay into various designs. It was like a giant cookie cutter with a spring on it. It would stamp the clay and a spring would release the cut clay and we would just keep stamping," Harold remembered.

"That took a lot of muscle. When I came on the scene, we converted the press to hydraulics."

When it came time to bake the tile, it would be stacked high inside the beehive kilns. The floors of the kilns were hollowed out to create troughs for the heat to run evenly throughout the kilns.

"They were coal-fired to approximately 1,800 degrees. It was so hot inside the kilns that flames shot out

of the chimney. Each kiln had a brick you could remove to create a peephole; to view three small clay cones. The cones were used to determine the heat," Harold recalled.

"When the first cone began to bend or drop, we knew we were getting close to the proper temperature. When the second cone went down we would stop firing the coal and coast awhile."

It took three weeks from the time the tile went into the kiln until it was time to remove it.

The first week's firing was called "water smoking." According to Russell Bogenholm's brother Gerin, this first step burned out the impurities in the clay.

The second week involved the high temperature firing that bent the test cones. Gerin Bogenholm recalled how labor intensive this firing process was.

"Twenty-four hours a day, for one solid week, we fired the kiln with coal. It was all hand shoveled. In the summer months, the heat was nearly unbearable."

After the tile baked it took another week before the kiln cooled down enough to allow workers to retrieve the tile.

The tile closest to the fire box received the famous "fire flash" trademark.

"The red and brown tiles would get a little black tinge to them around the edge," Harold explained. "Fire flash was a special order and very popular. When we switched from coal to gas, we lost the fire flash tiles."

"The first run of tile that came out was pure brown. There was no fire flash at all. So, the coal oxidation process

had something to do with the fire flash. To cure that, toward the end of the gas firing ... we would remove the gas burners and stoke the fire with coal to get the fire flash back. It worked."

"Fire Flash" Tiles

Frank Johnson is credited with the creation of Nemadji's famous "fire flash" tile.

The earthen colors and handmade character of Johnson's fire flash tile melded beautifully with the Arts and Crafts Movement.

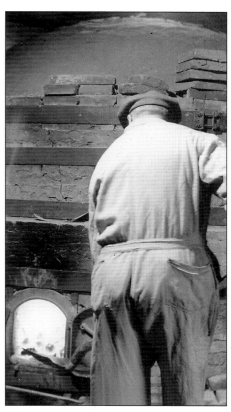

C. J. Dodge feeding a kiln at Moose Lake, circa 1938.

— COURTESY OF MORITA (DODGE) LARSON

NEMADJI TILES
Unglazed
The Most Beautiful Unglazed Tiles
(ASK THE ARCHITECTS)

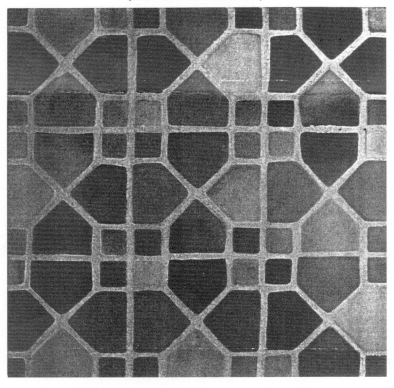

Pattern No. 12 in full range of color
This pattern is formed of **4″x 4″** tiles cut to shape while soft and 2″x 2″ tiles
Each of the square units will approximate 8½″x 8½″
Also available in 6″ points.

Nemadji Tile & Pottery Co.

Factory and General Offices: *Sales Office:*
 Moose Lake, Minnesota 409 Griswold St., Detroit, Mich.

See reverse side for other stock patterns

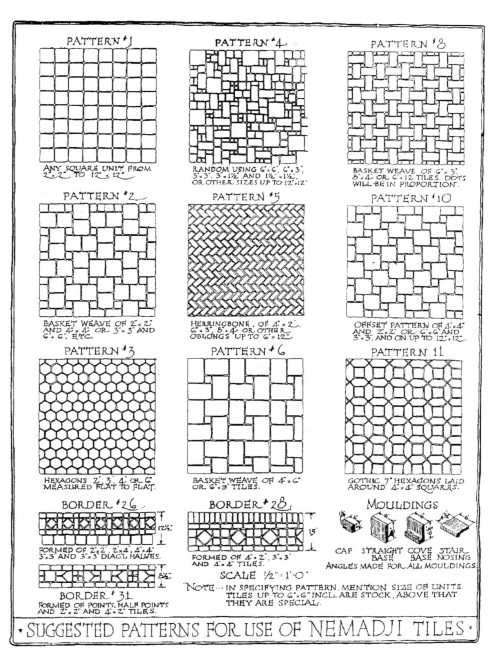

PATTERN #1
ANY SQUARE UNIT FROM
2"×2" TO 12"×12"

PATTERN #4
RANDOM USING 6"×6", 6"×3",
3"×3", 3"×1½" AND 1½"×1½",
OR OTHER SIZES UP TO 12"×12"

PATTERN #8
BASKET WEAVE OF 6"×3",
8"×4" OR 6"×12 TILES. DOTS
WILL BE IN PROPORTION.

PATTERN #2
BASKET WEAVE OF 2"×2",
AND 4"×4" OR 3"×3" AND
6"×6", ETC.

PATTERN #5
HERRINGBONE, OF 4"×2",
6"×3", 8"×4" OR OTHER
OBLONGS UP TO 6"×12".

PATTERN #10
OFFSET PATTERN OF 4"×4"
AND 2"×2" OR 6"×6" AND
3"×3", AND ON UP TO 12"×12".

PATTERN #3
HEXAGONS 2", 3", 4" OR 6"
MEASURED FLAT TO FLAT.

PATTERN #6
BASKET WEAVE OF 4"×6"
OR 6"×9" TILES.

PATTERN 11
GOTHIC 7" HEXAGONS LAID
AROUND 4"×4" SQUARES.

BORDER #26
FORMED OF 2"×2", 2"×4", 4"×4",
3"×3 AND 3"×3 DIAGL HALVES.
12½"

BORDER #31
FORMED OF POINTS, HALF POINTS
AND 2"×2" AND 4"×2" TILES.
8½"

BORDER #28
FORMED OF 4"×2", 3"×3"
AND 4"×4" TILES.
15"

SCALE ½" = 1'-0"

MOULDINGS
CAP STRAIGHT COVE STAIR
BASE BASE NOSING
ANGLES MADE FOR ALL MOULDINGS.

NOTE... IN SPECIFYING PATTERN, MENTION SIZE OF UNITS.
TILES UP TO 6"×6" INCL. ARE STOCK, ABOVE THAT
THEY ARE SPECIAL.

· SUGGESTED PATTERNS FOR USE OF NEMADJI TILES ·

Nemadji Tile Catalog, circa 1929.
— COURTESY OF UNIVERSITY OF ILLINOIS ARCHIVES

Examples of Nemadji tile can still be seen in Moose Lake. It was used as wainscoting inside the city's high school and as flooring at Hope Lutheran Church. It was also used in several local homes.

At Stanford Dodge's former home on First Street in Moose Lake, it is used extensively in the entryway and on the fireplace hearth. This beautiful mosaic of rich earthen colors is admired by all who enter the house. Despite its age, the tile has stood the test of time.

Nemadji floor tile was also used in dozens of churches nationwide and in Canada.

Those churches included St. Benedict's Church in Baltimore, Maryland; Church of the Little Flower in Detroit Michigan; St. Thomas Church in Denver, Colorado; and the Third Church of Christ Scientist in Houston, Texas.

One of the Midwest's premier architects, George P. Stauduhar (1863-1928), was a supporter of Nemadji tile.

Stauduhar received his degree in architecture from the University of Illinois in 1888. He established his offices at Rock Island in 1890 and set about the work of designing homes, office buildings and more than two hundred churches in the Midwest.

Stauduhar specialized in Roman Catholic churches in the "Neo-Gothic Revival" style.

An early Nemadji Tile and Pottery catalog was found among his many architectural drawings, technical papers and personal papers donated to the University of Illinois Archives by his family in 1976.

Nemadji tile was also used extensively in an Arts and Crafts Mission style retreat built for the National Girl Scout Council in Wisconsin.

While prices for the Moose Lake tile could be negotiated, a price list dated March 1,

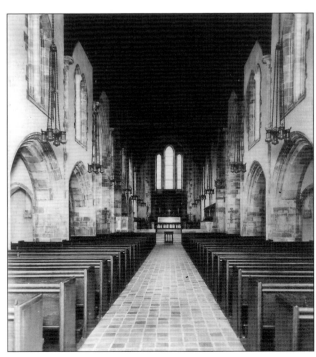

Nemadji floor tile in Emmanuel Episcopal Church, LaGrange, IL.
— COURTESY OF HAROLD WAHLSTROM

1939, indicated the quarter-inch, 2 ³/₄" square tiles mounted on paper sold for 60 cents a square foot.

Loose tile sold for just 35 cents a square foot.

A recipe for cleaning the tile was included with each shipment. It recommended using a solution of one pint of muriatic acid to one gallon of water. Not surprisingly, safety precautions included rubber gloves and eye goggles. The next steps included a rinse with clear water and when dry the application of several coats of good grade wax.

The above recipe was printed in 1939 before today's modern cleaning agents were developed. This author does not recommend the above recipe for cleaning and urges tile owners to contact a professional cleaner for advice.

Nemadji Pottery

While the tile operation was fairly sophisticated for its time, that wasn't the case for pottery production.

The first pottery made at Moose Lake was made the old-fashioned way by hand, on a foot powered fly-wheel. These early products did not have the distinct, painted surface Nemadji is known for today. Johnson's earthenware items were utilitarian and were sold primarily to local immigrants who settled in the Arrowhead region of Minnesota.

According to Johnson's daughter Frances, these pieces included flower pots, vases and salt-glazed crocks and bowls.

By the late 1920s demand for the pottery began to outpace production. The growing popularity

The growing popularity of Johnson's hand thrown pottery would ultimately severe the Johnson-Dodge business association.

of his hand-thrown pottery would ultimately sever the Johnson-Dodge business association.

The decision to end the partnership came when Dodge suggested a plan to create molds and expand into the tourist trade. The idea of mass production didn't sit well with Frank Johnson, the artist. He'd had enough of that at Red Wing and had no intention of compromising his beliefs.

With a close eye on the bottom line, Dodge refused to compromise as well. Ultimately this "business versus art," standoff ended with Johnson leaving the firm.

When a teaching position at a private school in New York was offered, Johnson took it.

At the time of Johnson's departure, the Nemadji tile operation had developed a significant national customer base. But without an experienced ceramist, Dodge knew it would be impossible to grow his new pottery line.

Faced with this dilemma, Dodge did the only thing he could do – he set out to find a replacement for Johnson, one who could appreciate and help carry out the dreams of a businessman. 🐃

The Dane Potter

C.J. Dodge's journey to find a new potter took him to Springfield in Southwestern Minnesota, where he met Eric Hellman. Hellman was working as a farmhand and part-time worker at the A.C. Ochs Brick and Tile Company.

Dodge found the recent immigrant from Denmark kneeling beside an old farm implement, tipped on its side. With a little bit of ingenuity, Hellman had jerry-rigged a corn shelling machine into a potter's wheel.

The revolving fly-wheel was perfect for throwing small vases and bowls.

Dodge approached Hellman and asked if he would consider taking a job at the Nemadji Tile and Pottery Company at Moose Lake, Minnesota.

At first the young Hellman was reluctant to make the move.

When he immigrated to America, Hellman swore he was going to give up his profession as a ceramist, because of its harm to the lungs. But the offer presented by Dodge was far too attractive to turn down in 1929.

Lured to Moose Lake with the promise of expansive clay beds and a steady paycheck, Eric Hellman spent about a year working at Dodge's plant.

During his time at Moose Lake, Hellman threw pots on a foot-powered wheel and used them to create the molds for the plant's signature line of slip cast Indian tourist pottery that would eventually be sold in shops nationwide.

During the casting process, liquid clay was poured into the molds and allowed to stand. When enough of this clay hardened to form a pot, the remaining liquid was poured out.

Hellman taught unskilled workers at Moose Lake how to remove the pots from his molds and use a spatula device to smooth away their cast lines. He also showed them how to place the pieces on the potter's wheel and mop them down to give the appearance of being hand thrown. This was the last step before the firing process.

Eric Hellman also introduced what he called a cold "striped" painting process using enamel based paints. This process gave Nemadji its distinctive swirls, which set it apart from much of the tourist pottery available in the 1930s.

This painting process would also be used two years later for Hellman's own line of "Garden of the Gods" tourist pottery.

The pots were colored by placing them into a water filled tub containing different colors of synthetic enamels. Hellman used this type of paint because the different colors of synthetic enamel

didn't merge easily.

For his early Nemadji and Garden of the Gods pieces he used red, blue, yellow and black.

After their "color baths" the pottery was left to dry and in less than a day it was ready for tourists.

From the inception of Nemadji Pottery at Moose Lake, to the end of its production at Kettle River, Pittsburg® brand enamel paint was used to create its classic swirls. While it is not known for certain whether Hellman used Pittsburg® paint at his pottery studio in Colorado, when comparing the earliest pieces, this author found the colors similar in their vibrancy and clear delineations.

As mentioned, Hellman's painting process did set Nemadji apart from much of the inexpensive tourist pottery coming onto the scene, but its swirls were not unique.

Niloak Pottery

By design or happenstance, Nemadji was similar in appearance to Niloak Missionware pottery, which came onto the scene nearly two decades earlier.

Niloak Pottery Company was incorporated in 1911 in Benton, Arkansas. The word *Niloak,* pronounced "Ny-loke," is kaolin spelled backwards. Kaolin is fine-quality clay found in Arkansas, used

Looking at early Niloak Missionware catalogs on file with the Central Arkansas Library System's Butler Center, one can see many design similarities between the Arkansas pottery and the pottery produced later in Moose Lake.

in making pottery and a variety of ceramic products.

The pottery's founder, Charles D. Hyten, produced Niloak by combining different-colored clays in layers. Turning these multi-colored clays on a potter's wheel created its unique spiral patterns of color.

His skills as a ceramist also came to play during the firing process. Through experimentation Hyten found a method that allowed for an even firing of the various clays without varying degrees of shrinkage. This firing process was so unique, it was protected by patent with the United States government.

This satin-smooth, colorful pottery from Arkansas sold for $2 dollars or more apiece in major department stores such as Marshall Field's® in Chicago and The May Company in New York and Los Angeles. Hyten often demonstrated his talent at the wheel, at the invitation of these stores.

No two pieces of Niloak were exactly alike.

"A thing of

Niloak Pottery

ITS ORIGIN AND MANUFACTURE

 OMMON pottery wares have been manufactured in Arkansas for many years, but it may be of interest to the reader to know that the manufacture of Art Pottery in Arkansas, as well as in the entire South, is entirely new; the first successful line of Art Pottery being turned out by this pottery early in January, 1910. The pottery, located near Benton, Arkansas, twenty-two miles from Little Rock, is in the heart of large fields of potter's clay, and thus commands the world's attention for what may be expected from Arkansas in Art Pottery.

NILOAK POTTERY is made from kaolin (clay without sand), from which it derives its name, the word being spelled backward. It closely resembles the pottery made by the Indians, and, we judge by specimens of their pottery that the same clay must have been used, and, like their pottery, each piece is moulded by hand. Their crudeness being overcome by modern methods gives to our pottery perfect symmetry and individuality.

The process of coloring and mixing the clay which brings out the unique effects obtained is the secret of the manufacturer. No two pieces take the distribution of the coloring matter alike, thereby rendering each piece distinct. The prevailing colors are blue, brown, slate intermingled with white, forming a grain effect, and resembles petrified wood. The illustrations herein contained, while being the best obtainable, fail to do justice to the beauty of the ware itself. Fully realizing the possibilities and merits of this ware, we have secured the sole selling agency for NILOAK POTTERY.

In making your selections from the catalogue, please bear in mind that we cannot duplicate the cuts exactly, but will endeavor to do so as nearly as possible.

F. W. SANDERS & CO.
Little Rock, Ark.

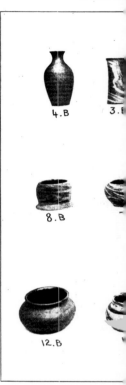

4.B 3.

8.B

12.B

Illus

Niloak Pottery Catalog, F.W. Sanders & Company,
Little Rock, Arkansas.
— COURTESY OF THE BUTLER CENTER FOR ARKANSAS STUDIES

Two years after its founding in 1910, the Niloak Pottery received national recognition with the cover story in *The Clay-Worker,* labeled "Mission Art Pottery."

Questionable Advertising
It is thought that the "Mission" tag was provided by the stores that sold Niloak.

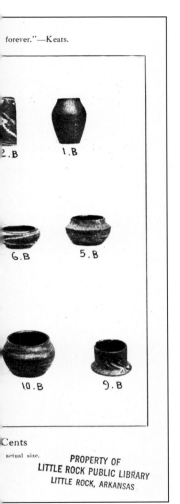

forever."—Keats.

2.B 1.B

6.B 5.B

10.B 9.B

Cents

actual size.

When large stores sold the pottery, they often came up with exotic prose to advertise it. "Egyptian. Made in the Valley of the Niles" ... similar promotions for Nemadji drew comparisons between it and Indian made pottery.

According to an article written by David Edwin Gifford and printed in the *Antique Journal* in August 1973, when large stores sold the pottery, they often came up with exotic prose to advertise it. "Egyptian. Made in the Valley of the Niles," read one store label.

A catalog, printed by F.W. Sanders and Company of Little Rock, included the story of Niloak's origin and manufacture using kaolin clay:

"It closely resembles the pottery made by the Indians ... we judge by specimens of their pottery that the same clay must have been used, and, like their pottery, each piece is moulded (sp) by hand."

Similar promotions for Nemadji also drew comparisons between it and Indian made pottery.

Looking at early Niloak Missionware catalogs on file with the Central Arkansas Library System's Butler Center, one can see many design similarities as well between the Arkansas pottery and the pottery produced later in Moose Lake.

Did Dodge and Hellman take a page or two from the early Niloak catalogs to design and promote their own Nemadji tourist pottery?

The answer to that question may never be known as both men took it to their graves.

We do know that Niloak and Nemadji are beautiful to look at and hard to resist. And thanks to Eric Hellman's talents as a ceramist and mold maker, Nemadji pottery was a lot easier to produce and a lot cheaper for the tourists of the 30s to buy.

Garden of the Gods Pottery

In the spring of 1931, Eric Hellman was offered a job at the famous Van Briggle Pottery in Colorado Springs, Colorado. His task at Nemadji Tile and Pottery completed, he traveled west.

Van Briggle Pottery

The Van Briggle Pottery was established by Artus Van Briggle in 1901.

Van Briggle had been drawn to Colorado Springs two years prior for health reasons. As the story is told and retold, during a walk in the nearby hills he discovered some of the world's finest clays and decided to settle there.

During his earlier studies in Paris, Van Briggle discovered the beauty of Ming China porcelain on display in museums there. Through trial and error he unlocked the secrets of its ancient powder matte glazing process. He later perfected this process in Ohio and introduced it in Colorado at the opening of his pottery.

His early pastel pottery featured low relief designs inspired by native flowers. His most famous piece was named the "Lorelei," which featured the relief of a young woman with long flowing hair, embracing a vase.

German legends tell of a beautiful young woman, named Lorelei, who threw herself into the Rhine River in a fit of great sadness over an unfaithful lover.

Upon her death she was transformed into a siren and from that time on could be heard singing on a rock along the river. Her hypnotic music lured sailors to their death. The legend is based on an echoing rock that shares her name near Sankt Goarshausen, Germany.

Van Briggle's Lorelei piece and others produced at Colorado Springs continue to entice modern-day collectors. Many are displayed in museums around the world and command princely sums, just as the early Ming pieces the award-winning

Pikes Peak.
— COURTESY GARDEN OF THE GODS TRADING POST

Hellman was among the many artists hired by I.F. and J.H. Lewis to help develop new products and supply the growing demand for Van Briggle Pottery.

artist admired as a youth in Paris.

Van Briggle died of a lung ailment in 1904, but wife Anne, an accomplished artist in her own right, dedicated her life to perpetuating his work by creating a school to train young artists.

By the time Eric Hellman arrived at Van Briggle, the operation had been the subject of a sheriff's sale and had undergone at least two ownership changes.

Hellman was among the many artists hired by I.F. and J.H. Lewis to help develop new products and supply the growing demand for Van Briggle Pottery.

His duties there included demonstrations. As the tourists came through the Van Briggle plant, they could watch Hellman and other artists sitting at the potter's wheel

using their hands to mold the spinning lumps of moist clay into pottery. In later years, Hellman told his wife Verna he didn't like demonstrating as it made him feel like "a monkey in a cage."

Hellman's Studio at the Strausenback Indian Trading Post

Whether it was the discomfort of being on display or his desire to make his own way, Hellman's stint at the pottery was short-lived.

He left Van Briggle Pottery on North Nevada Avenue within a year to set up his own studio on the grounds of the Strausenback Indian Trading Post near world-famous

Trading Post. – COURTESY GARDEN OF THE GODS TRADING POST

Hellman left Van Briggle Pottery on North Nevada Avenue within a year to set up his own studio on the grounds of the Strausenback Indian Trading Post near world-famous sandstone rock formations, known as "The Garden of Gods."

sandstone rock formations, known as "The Garden of Gods."

In the early 1900s, Charles E. Strausenback, while still in his teens, set up a tripod stand at the Garden's East Gateway Rock. There he sold gypsum figurines which he carved.

This was the beginning of the Garden of the Gods Trading Company.

In 1924, plans were underway to create "an Indian Pueblo curio museum." According to the literature of the day, its purpose was to be a showplace "so that eastern people who did not have the opportunity to visit the rest of the great Southwest might have the opportunity to study the Indian Pueblo structures."

Pueblo Indians were employed to perform native dances and to make baskets and pottery at the new shop. Navajo men and women were hired to weave blankets and create silver jewelry.

Garden of the God's Trading Post

In 1979, the Trading Post came under new proprietorship. T.A.T. Enterprises, Inc., began extensive renovations. In the tradition of the original Trading Post, a Southwest Indian Art Gallery was built to display contemporary Indian fine arts and crafts. The main structure was left much as it had been in earlier days.

Today an estimated 200,000 people visit the post each year. It remains the top attraction at the south side of the world famous Garden of the Gods Park.

The 1,340-acre park is owned by the city of Colorado Springs. The site is a national landmark, recognized by the U.S. Department of the Interior as a "nationally-significant natural area."

The highlights of the Garden are its towering sandstone formations, a spectacular view of Pikes Peak and its living history museum.

The park was given to the city in 1909 by the family of railroad magnate Charles Elliot Perkins. It was his wish that the Garden be kept forever open and free to the public.

One of the most famous rocks in the country is Balanced

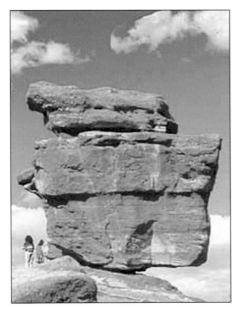

Balanced Rock.
— COURTESY GARDEN OF THE GODS
TRADING POST

Rock. A layer of shale left from mud that eroded at the base of the rock provides the small support on which the huge rock is balanced.

These formations are still accessible, free of charge to tourists from far-flung regions worldwide.

In 1932, Hellman's first pottery studio was built in the shadows of these spectacular sandstone "Gods." His studio was quite primitive, nothing more than four posts stuck in the ground with a piece of canvas to protect him from the elements.

It's difficult not to draw comparisons between Hellman's meager beginnings in pottery manufacturing at Colorado Springs and Bruce Kasden's story of the elderly Indian in a teepee in Arizona, outlined in chapter one of this book.

But whereas the Indian's pottery production using primitive resources was a myth designed to sell pottery to tourists, Hellman was the real deal.

Colorado Clay

The clay deposits near Colorado Springs were similar in color to those found in Northeastern Minnesota. It fired dark red to cream buff.

This local clay was described as being the exact colors used in ancient Persian pottery. The unique texture and chemistry of this clay allowed Hellman and other artists in the Colorado Springs area to use it without a preliminary firing.

Using this abundant local

Hellman's early hand-thrown pieces produced at the trading post are nearly indistinguishable to the Nemadji pottery produced in Moose Lake between 1929 and 1931.

resource to fashion small bowls and vases on his potter's wheel out in the open, Hellman would often draw a crowd of tourists visiting the trading post. The pottery was fired in a brick kiln built from demolition debris salvaged from junkyards.

When the pieces dried following

When Broadmoor Art and Tile Company opened its doors, Hellman joined the ranks of such nationally known artists as P.H. Genter, J.P. Hunt and Cecil Jones.

their special paint bath, they could be taken inside the trading post for purchase.

Hellman remained at Stausenback's tourist stop for less than a year.

In the winter of 1932, he went to work making tiles for Hassell Iron Works in exchange for a place indoors where he could produce pottery on a larger scale.

During his time at the Iron Works, Hellman expanded his wholesale customer base and despite the Great Depression managed to make a comfortable living for himself.

Hellman's early hand-thrown pieces produced at the trading post are nearly indistinguishable to the Nemadji pottery produced in Moose Lake between 1929 and 1931.

The clay and paint colors are similar, as are the marks left by the deft hand of the ceramist.

Broadmoor Art and Tile Company

During the time of his barter arrangement with the Iron Works, Hellman was approached by the leader of a group of investors establishing a new pottery operation in Colorado Springs. Their goal was to rival the famed Van Briggle Art Pottery.

The investors in the Broadmoor Art and Tile Company included W.B. Hassell, the president of the Iron Works and Spencer Penrose, the owner of the world-class, Broadmoor Hotel.

According to Hellman's wife, Penrose personally telephoned the potter and invited him to meet with the investors to discuss the start-up of this new operation.

When Broadmoor opened its doors, Hellman joined the ranks of such nationally known artists as P.H. (Paul Huntington) Genter, J.B. Hunt and Cecil Jones.

He worked there for approximately two years hand throwing art pottery.

Early promotion literature described Broadmoor pottery as "specialized artistic creations signed by the artists." The literature also stressed that "each piece was manufactured in limited editions."

Literature handed out to tourists who visited the Broadmoor plant also stated, "distribution of these creations is

handled only by select, creditable, outstanding distributors located in larger cities in America. In affiliation with such stores, the pottery is never sold at a reduced price."

A more expansive history of Broadmoor Art Pottery and Tile Company, its artists and photographs of several pieces signed by Eric Hellman, are included in Carol Carlton's "Collector's Encyclopedia of Colorado Pottery Identification and Values."

During the 1930s Hellman returned to Van Briggle for a short while and returned to Moose Lake, Minnesota, to assist the Dodge family in rebuilding a kiln. There was also discussion in the late 1930s to develop a profit-sharing agreement with C.J. Dodge to produce and sell swirl-painted tourist pottery nationwide.

Those discussions failed and both Hellman and Dodge continued to produce their individual signature lines.

Given his scientific training, it is not surprising to learn so many sought out Hellman for his expertise.

Hellman, the man
Born at Odense, Denmark on October 26, 1902, Eric Hellman went on to receive extensive training in the field of pottery and ceramics and worked in some of the world's most famous ceramics houses.

He graduated from Denmark's Technical Engineering Institute in 1924 at Copenhagen, earning his bachelor of science degree in ceramic engineering.

This was also the year the 22-year-old student competed in the Olympics as a member of the Danish Academy football team. He earned a bronze medal for his prowess on the field.

After leaving the Institute, Hellman traveled to Meissen, Germany, where he studied under Dr. Julius Bidtel, who operated a Ceramic School.

It was Dr. Bidtel whom many turned to for a professional opinion on whether regional clays were suitable for manufacturing.

One of those who sought his advice was the founder of Wisconsin's Pittsville Pottery, Father John Willitzer. The Catholic priest and German immigrant sent clay samples to Meissen for analysis. After study, the doctor gave his blessing to the American clay and in 1931 the Wisconsin Ceramic Company was incorporated.

Hellman earned his master's degree under the watchful eye of this world-renowned expert.

Meissen's skyline is dominated by the Albrechtburg Castle, thought to be the first castle used as a royal residence in the German-speaking world. The castle was built between 1472 and 1525.

It was in this idyllic settling that Hellman mastered the use of porcelain.

Prior to his arrival in America, Hellman also worked at the Royal Copenhagen Porcelain Manufactory. At the time he would have worked there, the manufactory focused on two predominate styles, art deco and functionalism. During this time,

During his career ... his creation of the mass-produced Nemadji and Garden of the Gods tourist pottery made "art" pottery available to the American masses.

Hellman had the opportunity to observe such master artists ply their crafts as Kai Nielsen, Arno Mainowskii, Jean Gauguin and Axel Salto.

These lessons learned in Europe were put to the test in America and Hellman passed with high marks.

During his career as a ceramist he worked alongside some of the greatest American artists of the 20th Century and his creation of the mass-produced Nemadji and Garden of the Gods tourist pottery made "art" pottery available to the American masses.

Hellman was also sought out to lecture at universities on the fine art of ceramics, and at the age of 41, he enlisted in the Army to serve his adoptive country during World War II.

As part of the war effort, Hellman was sent to the Battelle Memorial Institute in Columbus, Ohio. There he conducted ceramics research.

His efforts earned him the Ordnance Distinguished Service Award for Science and Engineering achievement.

After the war he returned to Colorado Springs, where he again produced his trademark swirl-painted Garden of the Gods tourist pottery.

Hellman was still an active potter into his early 80s, using both hand and slip cast methods of production.

At the peak of his career, Hellman claimed he produced as many as 60,000 pieces of his tourist pottery a year.

Prior to his death in 1985, Hellman was known as Colorado's Grand Old Man of Pottery.

Selling the Myth

Nemadji Indian Pottery easily lent itself to the "Mission," style of decorating that was popular during the first half of the twentieth century. Most of the early pieces fired cream buff, with a pink to light yellow tint, to dark red in color and were covered with paint swirls of primary colors. They ranged in height from two to twelve inches.

With the help of Eric Hellman, C.J. Dodge had a beautiful product and one that was priced within the reach of most Americans. But during the early 1930s, there was a lot of tourist pottery to choose from and fewer tourists willing to trade their hard-earned dollars.

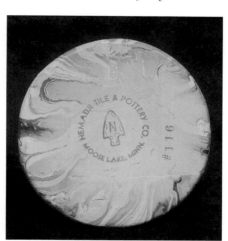

1929-1931 Nemadji Pottery.
ARROWHEAD STAMP MARK

Tourist Wars

Eric Hellman referred to this era as the "tourist wars," a time when merchants battled fiercely among themselves for their share of the shrinking trade.

In a letter written on April 28, 1930, C.J. Dodge reflected on the financial panic sweeping the nation. Writing to his son, James Edwin, who was attending the University of Minnesota he wrote:

"It is rather hard to explain just why a panic or dull times come on. The wisest men in the world are not sure of themselves on it, but it looks generally to the most well-informed people that last year we had an enormous stock speculation program on, and finally the bubble burst, with a loss of many billions of dollars in paper profits to speculators. These speculations were wide spread and it got people soured and some of them suffered quite severe losses and their continual propaganda and talk made people stop buying to a large extent, and when people quit buying the stores stop selling, and the manufacturer stops running and people get out of jobs and when they get out of jobs they buy less and less so that the thing acts like a chain, running in a spiral farther and farther down to the bottom and then

In these tough economic times Dodge knew to succeed he needed a hook to get his pottery onto the store shelves beyond Minnesota and compete in the highly competitive tourist industry. ... The hook was his pottery's ties to the ancient clay beds in the Land of the Ojibwe.

you have to slowly start up and work it up again all over. We have not yet devised a system to prevent that."

In the face of this economic spiral, Dodge remained optimistic. His letter included a plan to retrofit the tile and pottery plant.

"I know all the defects in the factory but do you know that with 7 or 8 men we can make an awful big profit there if things go right. One of the first things I am going to do is to get a flat suspended arch for those kilns. I am enclosing a circular that shows how these arches are made and I have written to find out how much they would cost. If I could have those arches on kilns like No. 5 & 6, and line the walls with fire brick they would never wear out. Furthermore with that pyrometer which is a wonder we can control our heat and in general we should have a 90% production out of the kiln. We have got that and better out of the factory now in green ware as there is very little loss indeed."

At the time of the introduction of Nemadji Indian pottery, tile orders were steady but nowhere near the rush seen in the mid to late '20s. The addition of the tourist pottery line was Dodge's attempt to bolster plant production enough to ride out the depression.

Nemadji Pottery
In these tough economic times, Dodge knew to succeed he needed a hook to get his pottery onto the store shelves beyond Minnesota and compete in the highly competitive tourist industry.

For nearly two decades, stores across America had successfully marketed Niloak "swirl" pottery as Indian and Mission pottery.

Dodge didn't hesitate to use a similar sales technique to promote his "Poor man's Niloak." The hook was his pottery's ties to the ancient clay beds in the Land of the Ojibwe.

Crafting his first written legend in 1930, Dodge used creativity and his knowledge of the law to implant the idea

Nemadji Pottery....

"Spend your vacations with us, in Northeastern Minnesota in the Arrowhead Country, in the land of the Ojibwas, in the land of smiling waters.

Twenty-five thousand years ago the last glacier began to retreat toward the north. This vast ice sheet blocked the eastern outlet of Lake Superior forming a large inland lake in the Arrowhead Country known as Glacial Lake Nemadji. From the bottom of this ancient lake, now a farming district, are secured the clays from which Nemadji tile and pottery are made. The natural colors of these clays when burned to high temperatures have made Nemadji floor tile famous. Research has shown us how to imitate the pottery made from these same clays by the ancient Ojibwe tribes who for long centuries ruled the Arrowhead Country. Our name *"Nemadji"* is an Ojibwe word.

Nemadji Pottery is made by skilled craftsmen whose deft hands throw pieces of clay on potters' wheels just as the Chinese centuries ago turned their pottery, which is today priceless. These craftsmen are under the direction of a skilled ceramist whose life has been spent in the production of pottery of an artistic type.

The coloring of Nemadji pottery is accomplished in a manner that allows no two pieces to be exactly alike, and furthermore, the skill and speed with which the ware is made places a hand turned, truly artistic piece of pottery within the reach of everyone.

The Nemadji Tile and Pottery Company is located at Moose Lake, Minnesota, on highway No. 61, 120 miles north of the Twin Cities and 45 miles south of Duluth. We invite you to visit our factory at Moose Lake, Minnesota, in the "Arrowhead Country", and see the interesting process of pottery making.

Nemadji pottery expresses the soul of the Arrowhead Country and of the Redman, who, though long since gone to the Happy Hunting Ground, still haunts our shores and woods."

— *Nemadji Tile & Pottery Co.* MOOSE LAKE, MN

that Hellman's creation had a direct connection to Native Americans.

Under C.J. Dodge's orders, each pot shipped from the Moose Lake plant carried with it a copy of his paper legend. And it seemed few tourists with an extra quarter could resist this documented proof of the

Dodge is also credited with adding stamps at the request of his customers in South Dakota which proclaimed that his pottery, "Contains Badland Clay," or "Native Clays," or "Nemadji Badlands Pottery Contains Badlands Clay."

pottery's ties to the "Noble Redman whose spirit still haunted the land" they were touring.

New Pottery Stamps

To further cement the relationship between Native Americans and his Nemadji Pottery, Dodge produced special stamp marks. The first was circular in shape, with an arrowhead and a capital N in the middle. The words, NEMADJI TILE & POTTERY CO. MOOSE LAKE, MINN, encircled the arrowhead. A second version used just the Arrowhead, with a capital N.

Another of his early stamps read "Hand Made Nemadji Indian Pottery (from Native Clay)."

Dodge is also credited with adding stamps at the request of his customers in South Dakota which proclaimed that his pottery, "Contains Badland Clay," or "Native Clays." One stamp read "Nemadji Badlands Pottery Contains Badlands Clay."

Another Dodge stamp read "Nemadji Blackhills Pottery." That stamp was used on the pottery shipped to shops in and around the Custer and Rapid City areas as well as to Wall, South Dakota.

To cover his bases, he also had rubber stamps made with the words "No. Dak." pottery.

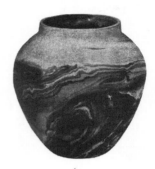
PLATE 1

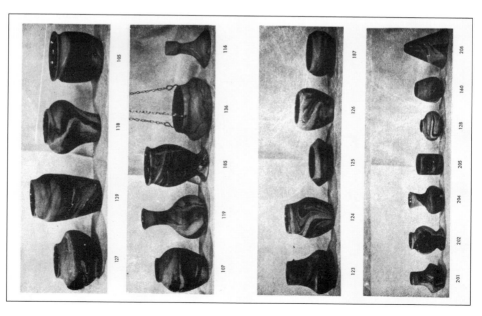

PLATE 2

Nemadji Pottery Catalog, Nemadji Pottery Company, Moose Lake, MN.
Circa 1960s, featuring many of the original designs created by Eric Hellman.

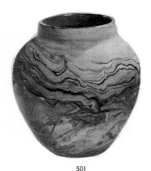
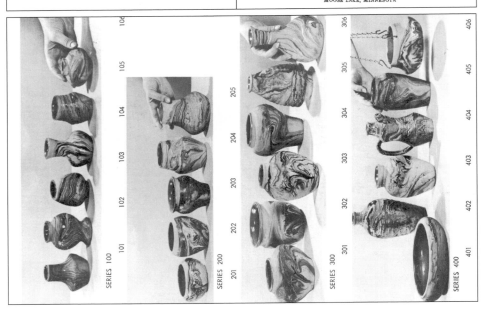

PLATE 3

Nemadji Pottery Catalog, Nemadji Pottery Company, Moose Lake, MN.
Circa 1969-1972.
NEW DESIGNS: #105, #305, #401, #402, #404

NEMADJI POTTERY

Twenty-five thousand years ago the ice sheet of the glacial age covered the land which we commercially speak of now as the Great Northwest, clear to the Missouri River. It is now known that the primitive ancestors of our present Indians lived here when the great ice sheet started to melt and retreat. Clays of various shades and composition were made by the glacial ice sheets; the great weight of the ice ground rocks and iron ore into dust, which became clays, afterwards washed and refined by the lakes and streams from the melting glaciers. From these clays Nemadji Pottery is made.

The Indians used this clay left by the ice sheet to make cooking pots and vases, and in the ancient warrior's grave are found fragments of his favorite cooking pot. Nemadji Art Pottery is made largely from designs of this ancient Indian pottery and many of their traditional shapes are preserved in our designs.

The coloring of Nemadji Art Pottery is accomplished in a manner that allows no two pieces to be exactly alike. The pottery is burned in a kiln and treated on the inside to hold water. The warm rich colors of this pottery recall the colorful costumes of the redman, who, though long since gone to the happy hunting ground, still haunts in spirit the plains, streams, woods, and lakes of this our Empire, the Great Northwest.

Catalogue

NEMADJI POTTERY CO.
HAND-MADE UNGLAZED ART POTTERY

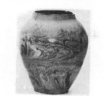

601

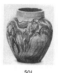

501

502

PLEASE ORDER BY NUMBER
ALL ORDERS RECEIVE PROMPT ATTENTION

See Enclosed Price List

NEMADJI POTTERY CO.
Phone (218) 273-4311 -- Kettle River, Minnesota 55757

PLATE 4

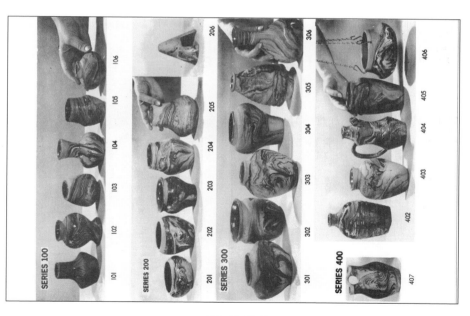

PLATE 5

Nemadji Pottery Catalog, 1973.

NOTE NEW DESIGNS: #601, #502, #407, #206

Old photos of pottery with shellac interiors were used in this new catalog.
Pots produced after 1973 have fired, clear glaze interiors.

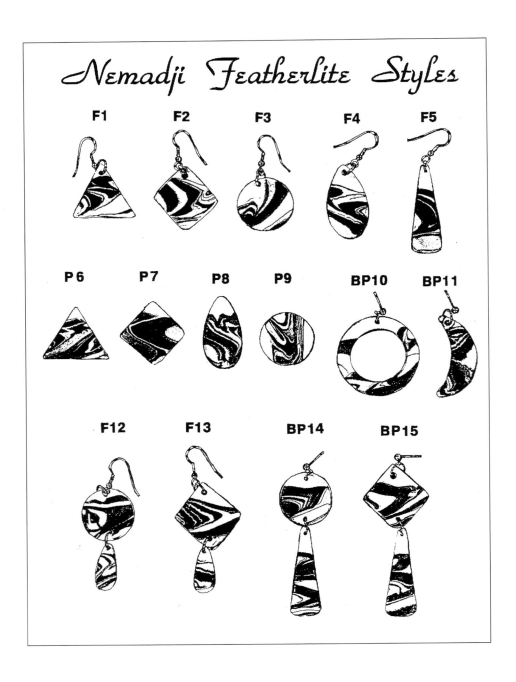

PLATE 6

1990s Nemadji Featherlite earrings.
White clay, non-glazed.

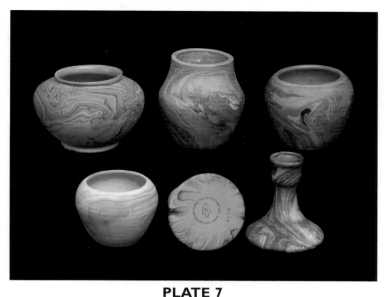

L TO R

TOP ROW:
#127, #124,
#126

BOTTOM ROW:
#126, #116

PLATE 7

1929-1931 Nemadji Pottery.
Arrowhead stamp marks. Colored clay, shellac interiors.
Hand-thrown and mold-ware.

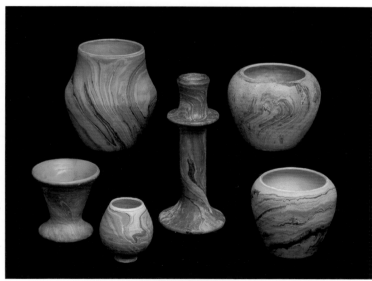

L TO R

TOP ROW:
#124, #126

BOTTOM ROW:
#203, #160,
candle stick,
#126

PLATE 8

1929-1931 Nemadji Pottery.
Arrowhead stamp marks. Colored clay, shellac interiors.
Hand-thrown and mold-ware.

L TO R

TOP ROW:
large jug,
pitcher, sugar
bowl

BOTTOM ROW:
small jug, cup
and saucer,
creamer

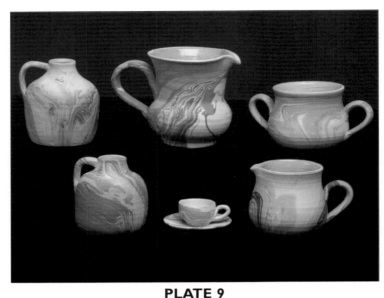

PLATE 9

1932-1940 Garden of the Gods Pottery.
GOG stamp marks. Colored clay, shellac and glaze interiors.
Hand-thrown and mold-ware.

L TO R

TOP ROW:
shoulder vase,
gooseneck vase

BOTTOM ROW:
small bowl,
large ovoid
vase, small
ovoid vase,
small Pikes Peak
vase, large bowl
with frog

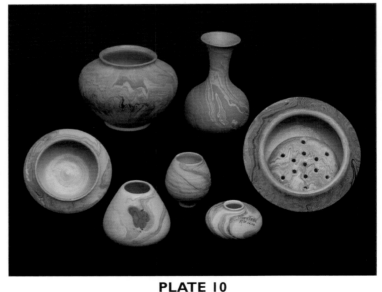

PLATE 10

1932-1940 Garden of the Gods Pottery.
GOG stamp marks. Colored clay, shellac and non-treated interiors.
Hand-thrown and mold-ware.

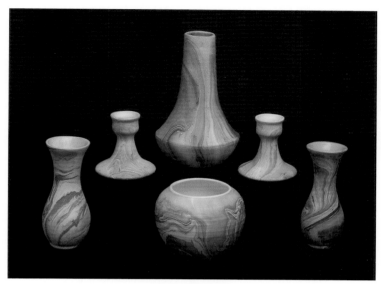

PLATE 11

1945-1982 Garden of the Gods Pottery.
GOG stamp marks. White clay, shellac, glaze and
non-treated interiors, mold-ware.

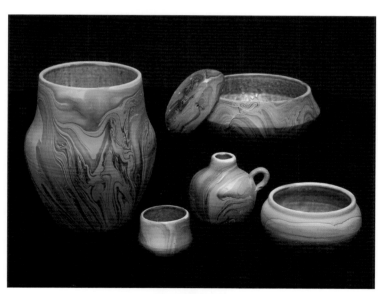

PLATE 12

1970-1982 Garden of the Gods Pottery.
GOG stamp marks. White clay, green glaze interiors, mold-ware.

L TO R

TOP ROW:
bowl with fired,
clear glaze
interior, #202,
jug with handle

BOTTOM ROW:
various vases
made with blue,
white and black
clays, fired, clear
glaze interiors.

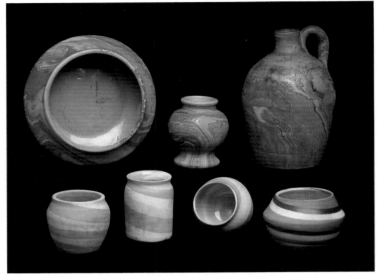

PLATE 13

1935-1947 Nemadji Pottery.
J. Edwin Dodge experimental pieces incised with initials. Multi-color clays.
Glaze and shellac interiors, hand-thrown and mold-ware.

L to R
Clockwise

#139, #107,
#204, #123,
#185, #136,
#187

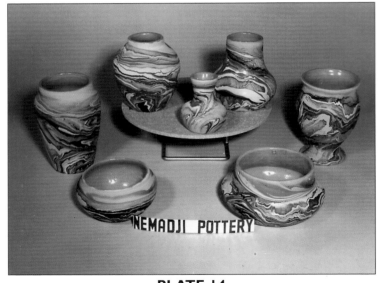

PLATE 14

Nemadji advertising photo, circa 1960.
Colored clay, shellac interiors, mold-ware.

— COURTESY OF HAROLD WAHLSTROM

L to R
#118, #123

PLATE 15

Nemadji advertising photo, circa 1950.
Colored clay, shellac interiors, mold-ware.

— COURTESY OF HAROLD WAHLSTROM

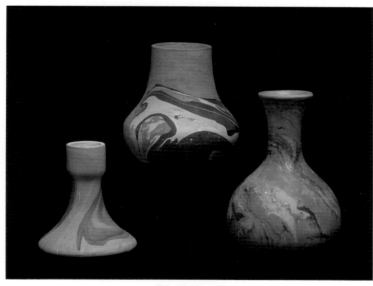

L to R
TOP ROW
#123
BOTTOM ROW
#116, #119

PLATE 16

1946-47 Nemadji Pottery.
Unmarked factory seconds collected by worker.
Colored clay, shellac interiors, mold-ware.

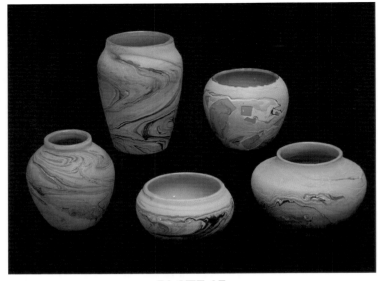

PLATE 17

1935-1949 Nemadji Pottery.
Blackhills and Badland stamp marks.
Colored clay, shellac interiors, mold-ware.

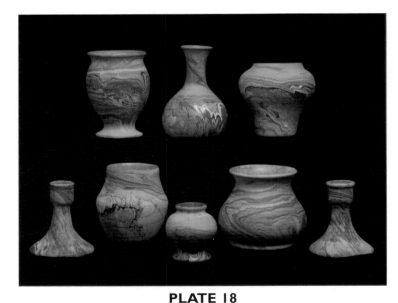

PLATE 18

1933-1949 Nemadji Pottery.
Badlands stamp marks. Colored clay, shellac interiors, mold-ware.

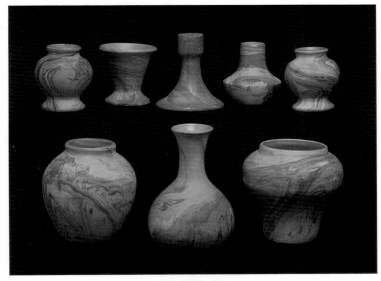

R to L

TOP ROW:
#202, #203,
#116, #201,
#202

BOTTOM ROW:
#107, #119,
#118

PLATE 19

1933-1949 Nemadji Pottery.

No. Dak. Stamp marks. Colored clay, shellac interiors, mold-ware.

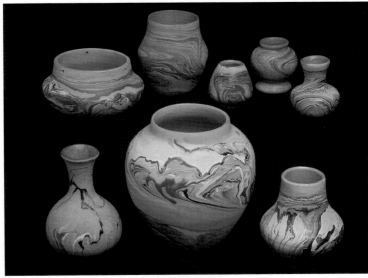

R to L

TOP ROW:
#136, #124,
#160, #202,
#204

BOTTOM ROW:
#119, #161,
#123

PLATE 20

1933-1948 Nemadji Pottery.

Handmade Nemadji Indian pottery (from native clay) stamp marks.
Colored clay, shellac interiors, mold-ware.

R to L

TOP ROW:
#123, #107

BOTTOM ROW:
#105, #204,
#125, #201,
#127

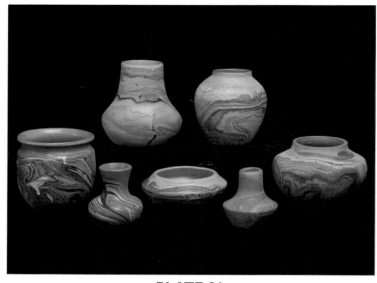

PLATE 21

1933-1969 Nemadji Pottery.

Nemadji Pottery mark. Colored clay, shellac interiors, mold-ware.

R to L

TOP ROW:
#204, #161,
#127

BOTTOM ROW:
#205, #201,
#128

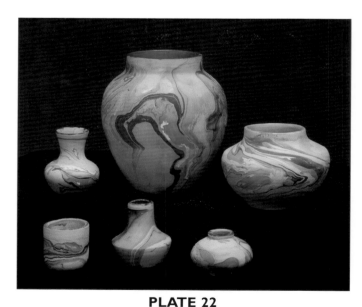

PLATE 22

1949-1969 Nemadji Pottery

Nemadji Pottery stamp marks

Red paint order. Colored clay, shellac interiors, mold-ware.

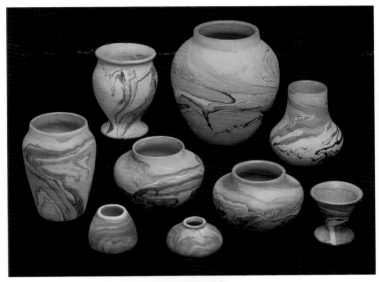

R to L

TOP ROW:
#185, #161,
#123

BOTTOM ROW:
#139, #160,
#127, #128,
#127, #203

PLATE 23

1949-1969 Nemadji Pottery.
Nemadji Pottery stamp marks. Brown paint order.
Colored clay, shellac interiors, mold-ware.

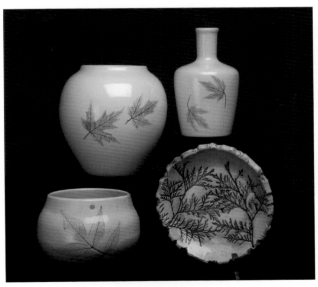

R to L

TOP ROW:
E-2, D-3

BOTTOM ROW:
D-6, C-3

PLATE 24

1982-1983 Nemadji Forest Impressions.
Indian head stamp marks.
White clay, clear glaze interiors and exteriors, mold-ware.

R to L

TOP ROW: F-1

BOTTOM ROW:
Electric lamp,
D-2, E-1

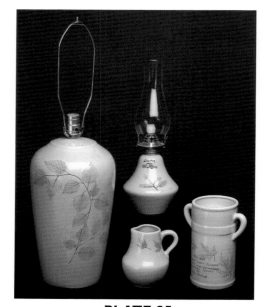

PLATE 25

1982-1983 Nemadji Forest Impressions.
Indian head stamp marks.
White clay, clear glaze interiors and exteriors, mold-ware.

R to L

TOP ROW:
Master mold,
Bird feeder

BOTTOM ROW:
Wrenshall
brick, plaster
mold for #204

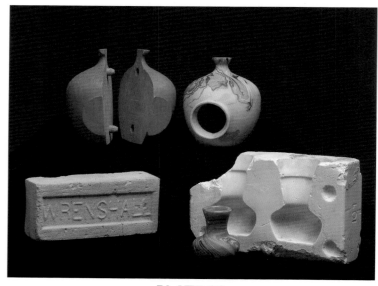

PLATE 26

1973-2001 Nemadji factory items.

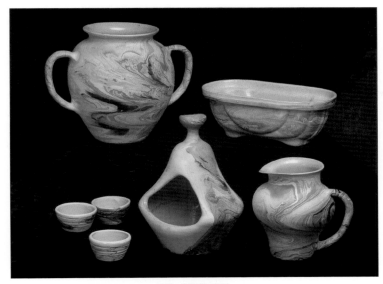

R to L

TOP ROW:
double handle vase and oblong vase, (Harvey Myre.)

BOTTOM ROW:
nut cups (H.M.), birdfeeder, (Alvin Siltenen), pitcher, (H.M.)

PLATE 27

1973-1980 Nemadji Pottery.
Variety of stamp marks. End-of-days.
White clay, clear glaze interiors, modified mold-ware.

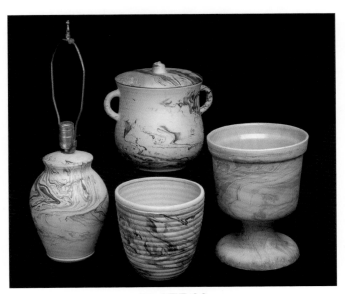

R to L

TOP ROW:
bean pot with lid

BOTTOM ROW:
electric lamp, beehive vase, large planter

PLATE 28

1973-1980 Nemadji Pottery.
Variety of Nemadji U.S.A. stamp marks. White clay, clear glaze interiors, mold-ware.

R to L

TOP ROW:
large vase,
incised
decoration

BOTTOM ROW:
pitcher, beehive
vase, large vase
with fired glaze
swirls (H.M.)

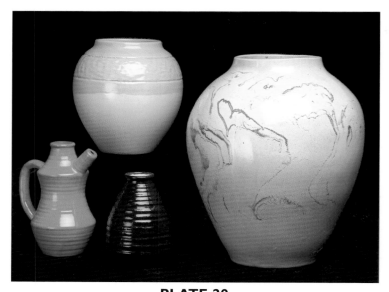

PLATE 29

1973-1990 Nemadji Pottery.

Experimental. White clay, interior and exterior glazes, mold-ware.

L to R

Top row:
#139, #118

Bottom row:
#136, #128,
#206 with
ashtray,
#127, Aveda®
special order

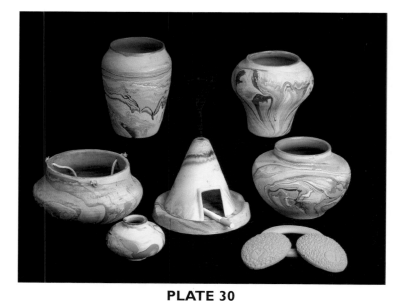

PLATE 30

1933-1995 Nemadji Pottery.

Variety of stamp marks.
Colored and white clays, shellac and glaze interiors, mold-ware.

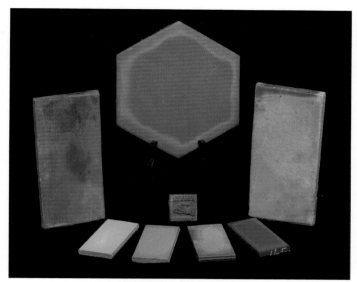

Nemadji floor tile.
Colored clay, non-glazed. Note fire-flash.

— TILE COURTESY OF WALT ANDERSON AND FRED FOLTZ

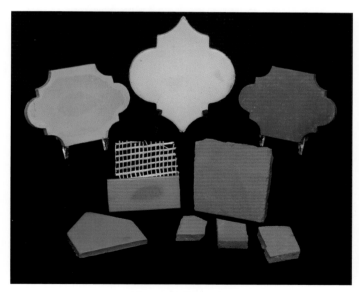

Nemadji floor tile.
Colored clay, non-glazed.
NOTE: The four glazed tile chards in the lower right hand corner
were dug at the site of the old plant.
They have not been attributed to Nemadji.

— TILE COURTESY OF W. ANDERSON, F. FOLTZ AND BOB HANSON

R to L

TOP ROW:
6" by 6",
8 ¹/₂" by 8 ¹/₂"

BOTTOM ROW:
2 ¹/₂" by 2 ¹/₂" in
box.

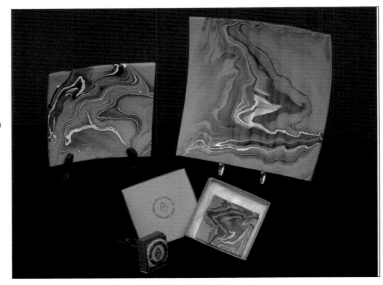

PLATE 31

1998 Nemadji Pottery.
75th Anniversary dishes. Commemorative Arrowhead stamp marks.
Colored clay, hand formed.

PLATE 32

1990-1995.
Nemadji Pottery Featherlite earrings. White clay, non-glazed.
Plaster Indian head, 3" by 4", as found at plant.

PLATE 33

1982-1983.

Nemadji cowboy and Indian caricature mugs.
White clay, clear glaze.

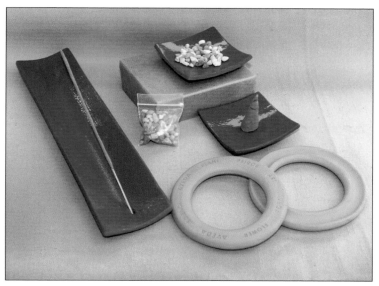

PLATE 34

1990s.

Nemadji created for Aveda®. Oblong incense burner.
Boxed set with gravel for fragrant oils. Light bulb ring.

L to R

TOP ROW:
taper holders

BOTTOM ROW:
Light house,
Saloon,
Adobe, Cactus,
Mushroom,
Cantina, Small
lighthouse

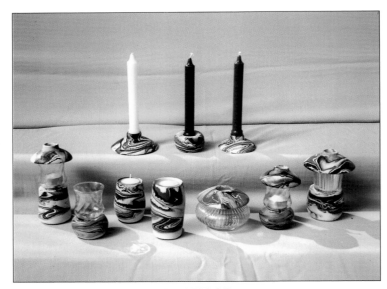

PLATE 35

1995-2002 Nemadji Pottery.
T-Lite lanterns. White clay, mold-ware.

Kettle River pottery show room sign.

Unpainted Nemadji.

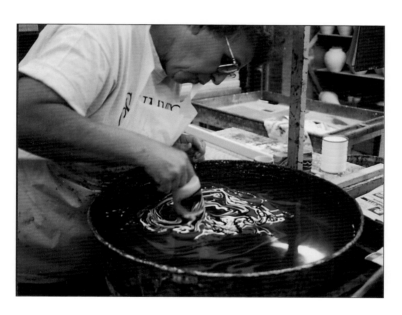

Margie Korpi painting pottery at Kettle River, 1997.

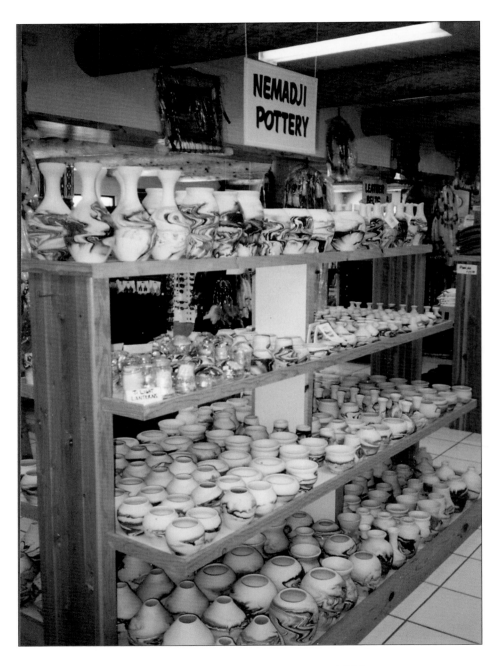

Nemadji retail display, New Mexico, 2000.
— COURTESY OF NANCY HANSON

Nemadji Earth Pottery

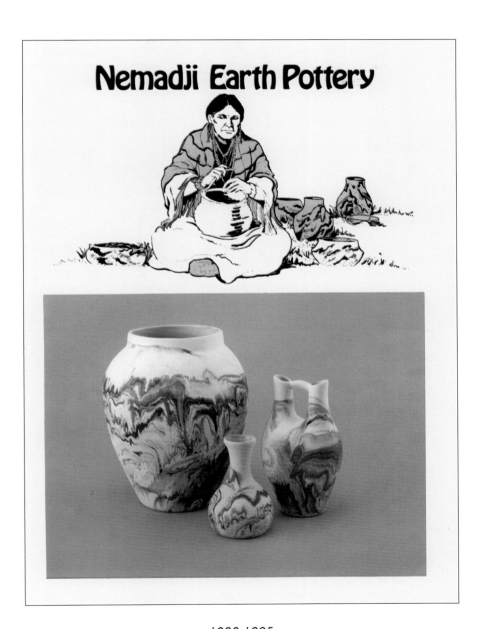

1980-1995.
Nemadji Earth Pottery. Indian head stamp marks.
White clay, clear glaze interiors, mold-ware.

PLATE 36

1980-1995.

Nemadji Earth Pottery.
Indian head stamp marks.
White clay, clear glaze interiors,
mold-ware.

SERIES 000

001 002 003 004

- Made from natural earthen clays
- Styled from Native American pottery
- All handpainted
- No two colors alike

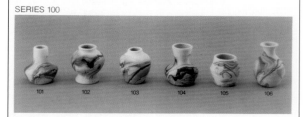

SERIES 100

101 102 103 104 105 106

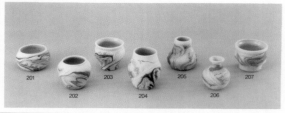

SERIES 200

201 202 203 204 205 206 207

PLATE 37

1980-1995.

Nemadji Earth Pottery.
Indian head stamp marks.
White clay, clear glaze interiors,
mold-ware.

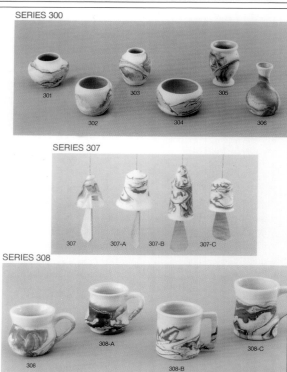

SERIES 300

301 302 303 304 305 306

SERIES 307

307 307-A 307-B 307-C

SERIES 308

308 308-A 308-B 308-C

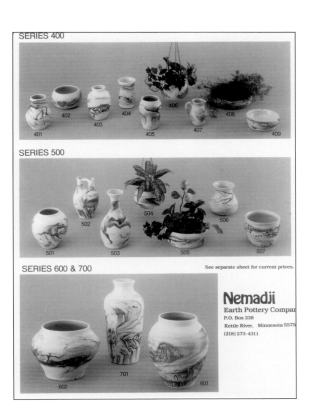

SERIES 400

401 402 403 404 405 406 407 408 409

SERIES 500

501 502 503 504 505 506 507

SERIES 600 & 700

See separate sheet for current prices.

Nemadji
Earth Pottery Compan
P.O. Box 238
Kettle River, Minnesota 5575
(218) 273-4311

701 602 601

PLATE 38

1980-1995.
Nemadji Earth Pottery.
Indian head stamp marks.
White clay, clear glaze
interiors, mold-ware.

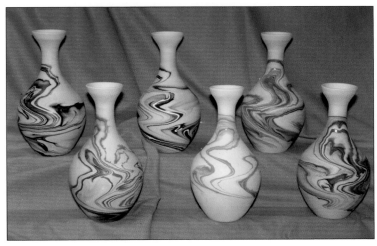

L TO R

TOP ROW:
teal, grey mist,
coral peach

BOTTOM ROW:
raspberry frost,
mint green,
tan mist

1995-2001.
Nemadji American Southwest. Indian-in-canoe stamp marks.
White clay, non-treated interiors, mold-ware

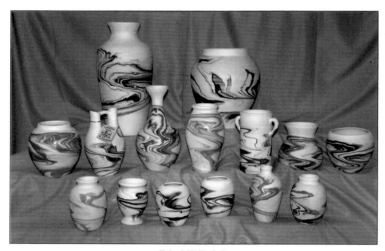

PLATE 39

1995-2001.

Nemadji American Southwest. Indian-in-canoe stamp marks.
White clay, non-treated interiors, mold-ware.

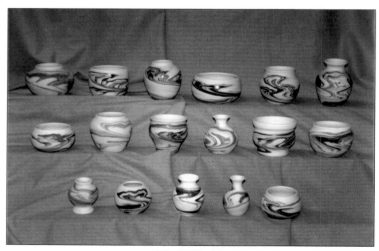

PLATE 40

1995-2001.

Nemadji American Southwest. Indian-in-canoe stamp marks.
White clay, non-treated interiors, mold-ware

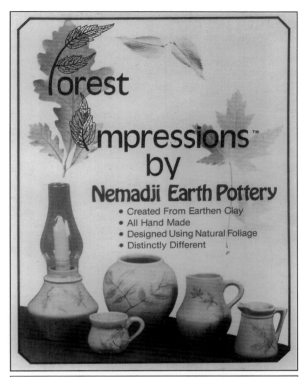

PLATE 41

1982-1983.
Nemadji Forest Impressions.
Indian head stamp marks.
White clay, clear glaze interiors
and exteriors, mold-ware.

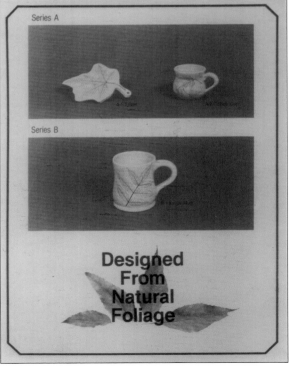

PLATE 42

1982-1983.
Nemadji Forest Impressions.
Indian head stamp marks.
White clay, clear glaze interiors
and exteriors, mold-ware.

PLATE 43

1982-1983.

Nemadji Forest Impressions.
Indian head stamp marks.
White clay, clear glaze interiors
and exteriors, mold-ware.

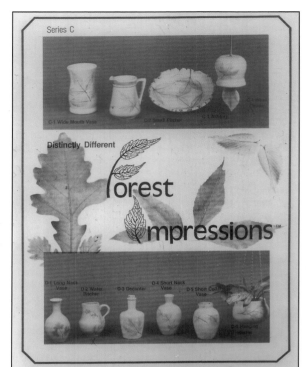

PLATE 44

1982-1983.

Nemadji Forest Impressions.
Indian head stamp marks.
White clay, clear glaze interiors
and exteriors, mold-ware.

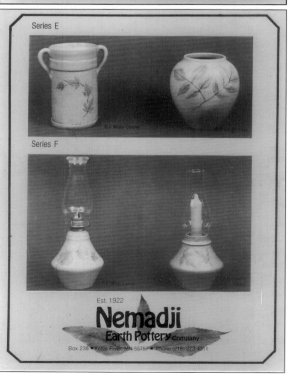

PLATE 45

1992.

Nemadji specialty line. Nostalgic Memories mug collection.

PLATE 46

1986.

Nemadji specialty line. The Great Outdoors wildlife mug collection.

The Great Depression

During the Roaring '20s and well into the 1930s, Nemadji's hand-made tile products were shipped nationwide. The tile's earthen tone with its trademark "fire flash" graced the homes of the wealthy and was also in demand for businesses, churches and schools.

In 1928, the tile plant sold over $7,000 worth of tile in the month of October and about $8,500 in November.

James Edwin Dodge

That same fall, C.J.'s son, James Edwin, began his studies at the University of Minnesota to earn a degree in mining and engineering.

During his first year at college the tile plant thrived. His father wrote:

"Orders are just pouring in to the factory since you left and we are somewhat behind. The boys are working at the factory today fixing pallets and will also pack out an order or two. They have 53 slabs to set up that they are behind on and we are also remodeling kilns #5 and #6, in fact we are almost tearing them down to the floor. The center wall between the two chambers will be built up of fire brick and we will probably put the doors in the ends of the chambers, one on each end, that will permit full crew setting and a full crew emptying the kilns, and also facilitate cooling off the kiln after it is burned. We therefore have only #7,

#8, #3 and #4 in operation and with these new mixes that have a lot of Blackhoof (clay) in, we will probably have some harder tile, but we will also run the risk of spoiling some tile before we get thru with it."

During his years at the "U" James Edwin's father wrote him weekly and on occasion enlisted his aid in solving problems at the tile plant.

In November 1928 C.J. wrote seeking advice:

"Dear Edwin: this is a business letter. We shipped some tile for St. Luke's Hospital in Cleveland last July and the

Nemadji floor tile at St. Catherine's College, St. Paul, MN.
— COURTESY OF HAROLD WAHLSTROM

order went up to the factory to ship these tile in red, brown, tan and gray but the factory evidently got some light colored tile in the floor and the architect now wants the tile taken out or stained dark. I suppose this is the yellow that the architect objects to. I do not know that our tile can be stained. It might be that manganese dioxide could be treated with some acid like sulphuric and the stuff painted on the tile. I am sending you by parcel post two pieces of 6 by 9 yellow. I wish you would see what you can do about this by asking some of the instructors and perhaps they would help you. If these tile(s) are broken in shipment it will make no difference. Just find out what to stain the tile with if it can be done which I doubt but it might be possible to stain the yellows so they would look dark for a while anyway until that architect forgets about it. Any dark color will be OK. Do this as soon as you can."

During his summers James Edwin returned home to work in his father's plant and became quite proficient at the potter's wheel.

The Depression Hits

By the end of 1930, the letters to James Edwin began to reflect the impact of the Depression.

"The tile business is slow and money slower," C.J. wrote. *"I never saw a bill so hard to collect. I am going to shut down the 20th of December, hope I can get enough to pay the men then. I have been paying out money as fast as I can to clean up current bills. Our shipments however were small in November."*

After the spring term in 1931,

> With the economy as it was, the call for construction materials was minimal even for specialty products like Nemadji tile.

James Edwin put his education on hold and returned to Moose Lake to work in his father's plant. He eventually worked his way up to the position of general manager. In the midst of the Great Depression, it must have been a difficult position to hold, especially for a 23-year-old man.

With the economy as it was, the call for construction materials was minimal, even for specialty products like Nemadji tile. When orders for tile slowed to a trickle, the decision was made to lay off the handful of men still working.

Dust-pressed Tile

James Edwin went back to the "U" and finished his degree. When he returned to Moose Lake, he worked with this father at the plant filling an occasional tile order and producing their slip-cast Nemadji Indian pottery, which by then had developed a following among the trading posts in the West. The younger Dodge also began the development of a new dust-pressed tile product.

C.J. wrote about this new tile product to his younger son, Stanford, who was attending the University of Minnesota. *"I do wish we could get that dust-pressed tile to*

Nemadji floor tile at the Girl Scouts retreat, Kohler, WI.
— COURTESY OF HAROLD WAHLSTROM.

going, because I am sure that we can sell that tile right and left, if we can get it hard enough and dense enough. There is an attraction for our colors, but considerable sales resistance due to the handmade character of the tile. I am just as sure of that as I am that I am alive. The ordinary person does not like a handmade tile; nearly everyone likes straight lines and mechanical perfection. I am not saying that this is the best taste, but it is certainly the prevailing one."

During his experimentation to create a modern tile for the masses, Edwin also kept busy throwing pots by hand, experimenting with color clays and swirl designs. Some of those pieces are reminiscent of Niloak's Missionware pottery.

James Edwin's sister, Morieta (Dodge) Larson, sold his hand-thrown pots and the plant's Nemadji Indian Pottery in a small log cabin, tourist shop on Arrowhead Lane in Moose Lake.

On the rare occasion that James Edwin's hand-thrown pots come on the market today, they command a

Despite Herculean efforts, the Dodge family failed to return Nemadji Tile and Pottery to its production levels prior to the Depression.

fair price with collectors. Several are displayed at the museum in Moose Lake.

In 1936, C.J. and James Edwin began the process of awakening their tile plant from its depression slumber. New dies were ordered to cut tile, national sales representatives were hired and a new tile catalog was prepared.

A year later, a call was placed to Eric Hellman in Colorado Springs to help build a new kiln at the Moose Lake plant.

In a letter to son Stanford, dated May 19, 1937 C.J. described the man who helped him create Nemadji's pottery line seven years earlier as a *"Dane who talks pretty good English for the time he's been here."*

The elder Dodge added, *"He is a rather peculiar fellow. He is staying at the house. He knows all about pottery and ceramics of every sort, and seems like an awfully nice fellow."*

Despite Herculean efforts, the Dodge family failed to return Nemadji Tile and Pottery to its production levels prior to the Depression.

When America entered World War II, tile and pottery production at Moose Lake and many other pottery operations ended and James Edwin enlisted in the Army at Fort Snelling.

Post-WWII

After his honorary discharge from the U.S. Army in 1945, James Edwin Dodge returned home and reopened the family's plant, calling back a number of the former workers.

James Edwin and his workers used the same raw materials and production methods used before the war. He also used the same pottery stamp marks created by his father C.J. over a decade earlier.

When the post-war economy began to boom, it appeared the Moose Lake operation might recapture its pre-depression success.

James Edwin's involvement with the plant however, would be short-lived. He died after a brief illness in October 1948 at the age of 38.

Newspaper Coverage

His brother, Stanford, who practiced law in Moose Lake, stepped in to oversee the operation of the plant.

In newspaper articles during this time, Dodge was optimistic that he could bring the Moose Lake plant back to its glory days. The following is an article published on June 16, 1949 in the *Moose Lake Star Gazette-Family Journal.*

"Artistic 'fire-flash' tile made in Moose Lake is still finding its way into homes, churches, schools and other buildings in far-away places.

"Just now the Nemadji Tile and Pottery Company is completing an order for 1,300 square feet of 4-by-12 inch tile that will be installed in a new school administration building in Seattle, Wash.

"Recently the firm shipped 1,800 feet of its tile to Florida, and from there it will be sent on to South America.

"Stanford Dodge, who has been supervising activities of the company since the death of his brother, Edwin, last October, said last week that he hoped soon to close an order for a sizeable amount of tile for a YMCA building under construction in North Dakota.

"In years past the company has supplied more than 10-thousand feet of tile for buildings in Father Flanagan's Boys' Town in Nebraska. Moose Lake tile is found in well-known church structures from coast-to-coast, including the Central Lutheran Church of Minneapolis.

"By and large, however, the general shortage of expert tile-setters, coupled with the high pay demanded by those who are still practicing the craft, has played hob with small manufacturers of artistic tile, and the Moose Lake firm is no exception.

"Once—some 20 years ago—it employed a crew of 35 men and used to ship by the carload. Then came the depression years during which the plant all but suspended operations. Today it has but six full-time employees, and one or two who work part-time.

> *"Moose Lake tile is unglazed and of the true fire-flash type; the 'flash' or multi-color effect being gained by direct fire in a coal burning kiln."*

"Mr. Dodge himself is a practicing attorney and is able to devote only a fraction of his time to the tile business.

"Moose Lake tile is unglazed and of the true fire-flash type; the 'flash' or multi-color effect being gained by direct fire in a coal burning kiln.

"It takes an expert tiler to 'set' it properly, and to obtain the best effects from the variety of shades available, that tiler had better be somewhat of an artist, too.

"Mr. Dodge says his firm's tile is not recommended for outdoor use, and not for bathrooms, either.

"'We have it in our own bathroom at home,' he said, 'and I rather wish we didn't.'

"But for fireplaces, vestibules and wainscoting many have found it highly desirable. With its subdued shades, the tile has a restful look, and it also has a

Nemadji Tile and Pottery Plant, circa 1940s, Moose Lake, MN.
— COURTESY OF HAROLD WAHLSTROM

quality of ruggedness that makes it ideal for game rooms, lobbies and the like. With oil or wax applied, it takes on a soft sheen.

"Church architects have found the Moose Lake tile fits in well with the effects produced by stained glass windows, and oaken woodwork and pews.

"'It takes time to make tile properly,' says Stanley Hultberg, foreman, who has been working at the plant since 1926. 'When we get a special order that can't be filled out of stock, it's 10 weeks at least before we can be ready to ship.'

"Clay trucked in from the nearby communities of Nemadji and Wrenshall must first be dried and pulverized. In dust form, it is put into the 'wet pan', a round affair about 12 inches deep and 8 feet in diameter, where water is added until the dust becomes a thick mud. Red oxide is added to obtain a reddish color, manganese for brown and limestone for yellow or green.

"The Nemadji clay is brown, while that from Wrenshall is gray.

"From the wet pan the mud is taken in wheelbarrows to a machine called the 'extruder'. This dispenses the mixture in ribbon form, 9 inches wide and up to three-quarters of an inch thick. The ribbon moves on a belt to

Stanford found dividing his time between his family's plant and his law practice did justice to neither. In 1949, the plant was sold to longtime employees Gil and Walt Bogenholm.

tables where men cut it into desired lengths, then place the pieces on trays for drying.

"When fairly dry – and that takes days – the pieces have to be 'faced' – that is, laid face-to-face on new trays, and hauled to another shed for further drying before they are ready for the kiln.

"First step of the kiln process is 'water smoking' and it, too, takes several days. It consists of removing the last traces of moisture from the tile with a slow fire.

"Then comes the 'oxidizing' process, during which the temperature in the kiln is kept at about 1200 degrees for 48 hours without let-up.

"The heat is next slowly brought up to 1975 degrees and held there for four to six hours to complete the hardening.

"Cooling of the tile has to be done very gradually to avoid breakage and usually takes five or six days, according to Hultberg.

"The kiln, built of fire brick, can accommodate up to 3,000 feet of tile set up on racks.

"Assisting Hultberg at the plant now are Forest Davidson, Eino Illikainen, Cecil Hayes, Forrest Skelton and Mrs. Gilbert Bogenholm.

"Skelton and Mrs. Bogenholm comprise the main force of the 'pottery division', which also has a salesman out on the road. Skelton comes in to 'pour' the pottery, a job that calls for considerable experience.

"Mrs. Bogenholm does the painting, and in that capacity is the artist of the organization.

"Pottery produced by the company can usually be distinguished by its brightness of color. It is sold as souvenirs in the resort areas of northern Wisconsin and Minnesota.

"The firm had its origin many years ago as a one-man enterprise in Nemadji. The late C.J. Dodge, a Moose Lake Attorney and father of Edwin and Stanford, became interested, invested some money in it, and was instrumental in moving the business from Nemadji to Moose Lake in 1923.

"For several years thereafter it was Moose Lake's most flourishing industry—and it may be again some day, Stanford Dodge believes, if some way can be found of popularizing the use of artistic tile."

Ownership Transfers to the Bogenholms

Stanford found dividing his time between his family's plant and his law practice did justice to neither. In 1949, the plant was sold to longtime employees Gil and Walt Bogenholm. A short time later, they were joined by Walt's son-in-law, Harold "Wally" Wahlstrom, who operated the pottery side of the business.

Production of tile and pottery continued at the Moose Lake facilities until 1972.

In Moose Lake, the lighter colored Wrenshall and the darker Nemadji clay were used exclusively to produce tile. Stockpiled clay was often shared by both tile makers and potters, which explains the multiple colors of early Nemadji pottery.

As mentioned earlier, brown Nemadji clay fired red to reddish brown. Wrenshall gray fired cream buff with either pink or light yellow tones. Mixers would also add a variety of products to the clay dust to enhance tile colors produced upon the firing. Red oxide produced

Brown Nemadji clay fired red to reddish brown. Wrenshall gray fired cream buff with either pink or light yellow tones. Mixers would also add a variety of products to the clay dust to enhance tile colors

a red color. Manganese was used to create brown and limestone for yellow and green. There are some early Nemadji pots that have this yellow green hue.

The colors could be further manipulated during the chemical reaction process within the kiln. As Eric Hellman explained during various interviews, those final manipulations, however, could not be controlled.

As we see in newspaper and television reports from the mid-20th century, the process used to make Nemadji Tile changed little during its years of manufacture.

Television Coverage

In 1967, The Moose Lake Tile Operation was the subject of a television news feature by reporter and anchor Glenn Maxham. The following is the actual script Glenn used to feature the plant on Duluth's WDSM television station.

"Moose Lake, Minnesota, is the home of the Nemadji Tile and Pottery Company. The state's only tile-making operation, it's owned by Walter Bogenholm and staffed by members of his family. The firm was established in 1920, the buildings are 1923 vintage and they show their age.

"We saw Bogenholm's grandson, Gary Olson, a college student and part-time worker in the factory, stacking clay bricks preliminary to their being ground for use in tile.

"The clay, once ground, is as fine as face powder. Two types are used: Nemadji brown clay, which comes from an area near the river of the same

Early civilizations discovered that this clammy, compacted clay soil that rejected all efforts at farming was indeed good for something.

name and Wrenshall gray, obtained from a pit near that city. The recipe calls for 8 portions brown to 1 portion gray per wheelbarrow load.

"Bogenholm's son, Jerry, demonstrated how color is mixed into the clay by a huge crushing and mixing machine. Iron oxide is added to produce a red coloration...

"Early civilizations discovered that this clammy, compacted clay soil that rejected all efforts at farming was indeed good for something. Clay vessels and objects of art were some of the first products designed from this material...but it wasn't long before primitive decorated tiles and tile floorings were developed. Although the methods of the Nemadji Tile and Pottery Company certainly wouldn't be called primitive, they're a long way from sophisticated. Most of the machinery is nearly a generation old.

"A lot of the work is still performed by hand in Bogenholm's factory ... testing for proper consistency and transferring from the mixer to a conveyor belt are hand operations.

"Bogenholm himself feeds the clay into a hungry looking grinder. It appears to be a tricky process but he's very adept at it.

"The clay comes out of the grinder in flat, narrow, continuous bars that are cut into lengths of about a foot for handling convenience ... and put on pallet boards for shaping and drying.

"Imperfect pieces are culled out at this point and set aside to be redone.

"The uncomplicated approach to manufacturing used in Bogenholm's factory is nevertheless successful. His floor and wall tiles are of fine quality and through sales representatives in all the major metropolitan markets, he does a brisk business. One recently completed order called for a full freight car of tile for a posh restaurant in Tampa, Florida.

"While some modernization plans are in the works, the Nemadji Tile and Pottery Company will very likely remain a simple family operation ... relying on human skills to create a product that sells because it's good.

And that's our story for tonight!"

Colorizing

The artistic signature of pre-1973 Nemadji Pottery is written in a swirl of primary colors.

A special process was used to blend and marbleize paint on the outer surface of the buff and dark color clay pots, which allowed Nemadji to stand up to its advertising claims that, "No two pots are the same."

"We got in trouble once," said Harold 'Wally' Wahlstrom, who operated the pottery for 20 years.

"A lady came in. She had a porch with two posts. She wanted two matching pots to place on either side of her entryway. We told her we couldn't help her. No, as hard as we tried to paint them the same, we never could."

Harold's wife, Dorothy, was in charge of painting the pots.

First, they'd fill a galvanized wash tub with water and Harold would then open the paint cans.

"We used Pittsburgh® Paint. I'd take a stick and dip it into the cans and the paint would drip onto the water and float," he said.

"We'd put a little vinegar in the water," Dorothy added. *"It would help the various colors of paint expand into each other. There were wide and narrow bands floating on the water."*

"Then Dorothy would blow onto the paint as it floated on the water. The paint would move outward, leaving a circle of clear water on the surface. She would then grab a vase and put it down

A special process was used to blend and marbleize paint on the outer surface of the buff and dark color clay pots

into the clear water," Harold related.

"The paint would then move back to the middle of the washtub and adhere to the pot. She would then twist it slightly as she pulled the pot out of the tub."

"I did thousands of them that was," Dorothy said with a laugh and a shake of her head.

When orders came in for the various shops, customers could select either a brown base color or a red base color.

The brown orders would have brown as a primary color. Small amounts of green, orange, black and blue were added to the mix. The red orders would have red as a primary color. The secondary colors for that mixture were green, black and cream or ivory.

Dorothy learned the Nemadji painting technique from her aunt, Eleanor, the wife of Walt Bogenholm. Mrs. Bogenholm was taught by Edwin Dodge, who in turn was taught this "cold stripe" technique by its creator, Eric Hellman.

The Fifties

When Japanese-made ceramic products began to flood the American market, potteries across the country found it hard to compete with these cheaper goods.

In order to support his young family, Harold Wahlstrom took a second job with Northwestern Bell.

Even though the imported goods remained popular, the pottery in Moose Lake managed to carve a special niche in the marketplace.

Westward Travel and Tourism

The renewed interest in Nemadji pottery coincided with post-war America's growing love affair with the automobile and a romanticized history of the Wild West playing out at the local picture show.

When the families of the '50s discovered the fun of touring in the family car in the "Wild West" and in "Indian Country", many wanted to buy small keepsakes that were native to the areas they visited along the nation's growing highway system.

Nemadji pottery was perfect "casting" for the role of keepsake.

Harold and Dorothy Wahlstrom hired sales representatives on a commission basis to promote their pottery to businesses catering to the tourism industry.

The representatives took orders during the winter from trading posts and tourist shops.

By spring, the Wahlstroms worked overtime filling orders, and their primitive pottery took its place beside other "Indian style" goods on store shelves in the Dakotas, Minnesota, Wisconsin, Nebraska and Arizona.

Pottery "Legend"

To help promote their product, the Wahlstroms printed a revision of C.J.'s paper legend which extolled the virtues of Nemadji Pottery.

Each shop owner was given a pad of these legends. When they sold a pot, they would give one to their customer.

As their parents did before them, this new generation of tourists continued the folklore surrounding Nemadji Pottery.

Throughout its history, many of the tourists who bought Nemadji pottery soon lost the small pieces of paper that gave its true history. But they remembered their pots had something to do with Indians and native clay. Displayed in living rooms across the country as tokens of their summer vacation in the West, the pottery was soon known simply as "Indian Pottery".

Knowing a good thing when they saw it, the shopkeepers who sold Nemadji pottery did little to clear up the confusion.

Every spring, shopkeepers rushed to stock their shelves with the primitive, colorful pottery.

To help promote their product, the Wahlstroms printed a revision of C.J.'s paper legend which extolled the virtues of Nemadji Pottery.

For two decades the Wahlstroms spent their weekends working in Moose Lake to meet the demand for their product.

"We tried to keep them crude. I apologize for that term but ... the cruder something looked the better it sold for us. That's what people wanted," Harold said. *"We used shellac inside. They weren't glazed, like they are today. Back then, people wanted Nemadji to be primitive.*

"I remember the sales reps. would worry we wouldn't meet orders because

I also worked for the phone company. But, we always managed to fill them."

During the week, Harold worked for the phone company in Duluth. On Fridays he'd drive 45-miles south to Moose Lake and prepare his mold-ware for the kilns. Working all weekend, he timed it just right to allow the molds to dry out before he could pour again.

"The kiln itself would hold 3,500 pots. We would fire six or seven times a year," Harold said. *"We repeated that schedule until we sold the business."*

Shop owners, hoping to cut out the middleman and his commission, would sometimes stop at the Nemadji plant in Moose Lake to order their stock.

"I remember a fellow came to the plant from North Dakota. He had a gift shop there," Harold said. *"He placed a large order and said he would pay me if I would deliver them out there, which I did. And, I'll always remember the wholesale*

NEMADJI POTTERY

Twenty-five thousand years ago the ice sheet of the glacial age covered the land. It is now known that the primitive ancestors of our present Indians lived here when the great ice sheet started to melt and retreat. Clays of various shades and composition were made by the glacial ice sheets; the great weight of the ice ground rocks and ores into dust, which became clays, afterwards washed and refined by the lakes and streams from the melting glaciers. From these clays Nemadji Pottery is made.

The Indians used this clay left by the ice sheet to make cooking pots and vases, and in the ancient warrior's grave are found fragments of his favorite cooking pot. Nemadji Art Pottery is made largely from designs of this ancient Indian pottery and many of their traditional shapes are preserved in our designs.

The coloring of Nemadji Art Pottery is accomplished in a manner that allows no two pieces to be exactly alike. The pottery is burned in a kiln and glazed on the inside. The warm rich colors of this pottery recall the colorful costumes of the redman, who, though long since gone to the happy hunting ground, still haunts in spirit the plains, streams, woods, and lakes of this our Empire.

1938-1980 legend.

cost of the smaller pots, 30 cents, because when I brought the order out to North Dakota, the guy started haggling prices. I picked up one of the pots he had on display in his shop. He was selling them for a dollar something. I said to him, 'Hey, I'll take the order back to Moose Lake before I sell it any cheaper.' And he said, 'Oh, I have lots of expenses.' And I said, 'Well, so do I.' And that's why I remember the price on the smaller pots."

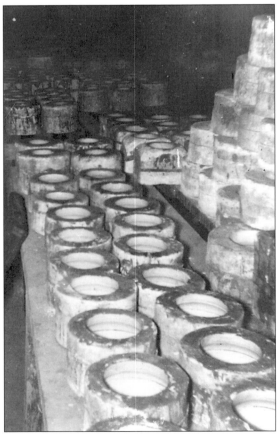

Pottery molds, at Nemadji plant, Moose Lake.
— COURTESY OF HAROLD WAHLSTROM

Wall Drug, South Dakota

Ted Hustead's Wall Drug in South Dakota was perhaps one of Nemadji Pottery company's biggest and most loyal customers.

In the early 1930s Hustead began to offer free ice water to sooth the parched throats of weary travelers who passed by his little drug store.

His hospitality worked, and those travelers quickly became customers. Today his store has grown into one of South Dakota's biggest man-made tourist attractions. Wall Drug sprawls across a full city block and other businesses have sprung up around it to accommodate the thousands who visit each year.

C.J. Dodge produced a variety of custom stamps for Wall Drug proclaiming the pottery contained Badlands Clay.

Hustead was also one of Harold Wahlstrom's customers during the '50s and '60s, spending thousands of dollars on the pottery. Wahlstrom eagerly supplied the product but refused to go along with the ruse used in the 1930s and well into the 1940s.

"Ted wanted me to stamp the pots, 'Contains Badlands Clay', but I wouldn't do it," he said.

"Remember, he sent us a little box of clay?" Dorothy added.

"That's right! He wanted

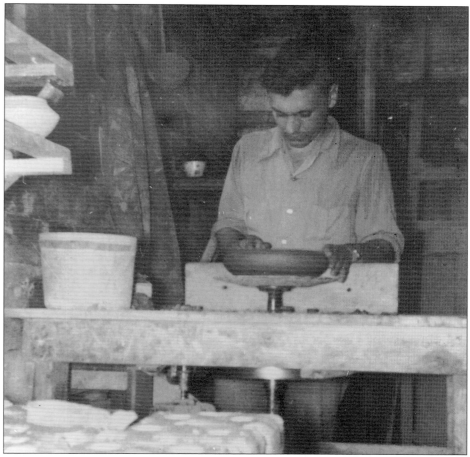

Harold "Wally" Wahlstrom, Nemadji plant, Moose Lake, circa 1950s.
— COURTESY OF HAROLD WAHLSTROM

me to take a small spoonful of the clay and dump it into the big mixing vat that held our slip for the molds. 'Just put a spoonful in each batch,' he told me. But, I said, ' No. I couldn't do that.' Oh, that Ted, he was quite a promoter."

The Wahlstroms also tell about one shop owner who wanted them to use pine scent on their pottery.

"I had an oil can that I put the scent in and squirted the bottoms of the pots so they would smell good. But that idea got us into trouble. There was a minister somewhere who bought one of the scented pots and placed it on top of his piano. The oil from the scent took the finish off, leaving a small ring in the wood. That cost us some money," Harold laughed. *"After that, we refused to make them smell good."*

Harold was in charge of making the pots and Dorothy painted them. Each day she and Harold would inspect their finished product.

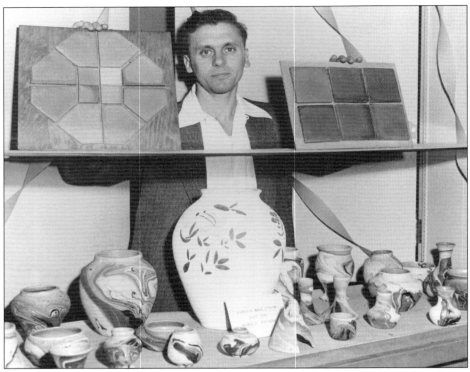

Harold "Wally" Wahlstrom with Nemadji products, circa 1950s.
— COURTESY OF HAROLD WAHLSTROM

"When we painted, there were certain ones we thought didn't look good," Harold explained. *"We put them aside and we'd say we won't ship those because they weren't what we liked. But, someone came in and bought them all ..."*

"That's right, they did," Dorothy added.

"When it came to our pottery, everybody had a different opinion," Harold said shrugging his shoulders.

Hundreds of the pots fired and painted in Moose Lake did not reach the eager hands of tourists. The late Skip Hanson, the former editor of the *Arrowhead Leader* newspaper in Moose Lake told this story:

"Back in the '50s we used to play in the dump near the pottery plant. There were piles of Nemadji pottery. I suppose they were seconds. But, they looked pretty good to me. Anyway, a bunch of us kids would take the pots and set them upright. We'd then throw rocks at them. We broke hundreds of those pots. I wish I had a few of those pots today," he added. 🐾

Recycling Pioneers

A ll of the pottery produced before 1972 received an interior treatment using shellac.

"They poured shellac inside of the finished pots, swished it around and then poured it out," Harold Wahlstrom related. *"When Dorothy and I took over the pottery we continued the practice. We even had a reclaimer to recycle the shellac that was poured out. Nothing went to waste."*

With each use, the shellac picked up tiny particles of fired clay dust and grew darker, which explains why the interiors of some of the old pieces of pottery have various shades of color including buff, butterscotch and dark red.

Wahlstrom also recycled when it came to securing the clay used to make his pottery.

"We went up to the Wrenshall Brick Factory and bought their seconds," Harold explained. *"These were unfired brick that had cracks or breaks. The owners of the factory would place these unfired brick on pallets for us. We would take them down to Moose Lake and grind them up into powder and begin the clay-mixing process for the pottery."*

The brick seconds were used for

Wrenshall bricks await pulverization at Nemadji plant, Moose Lake.
— COURTESY OF HAROLD WAHLSTROM

In 2003, Harold was still mixing clays and pouring slip into molds. Dorothy taught a variety of classes in their shop (D & H Ceramics)...

many years at the pottery. But when the Wrenshall Oil Refinery opened, it offered high wages and soon, all of the brick workers quit and went to work for the refinery.

"We had to hire a contractor to dig the clay and bring it to Moose Lake," Harold said. *"From the '40s to the time we sold the pottery we mostly used Wrenshall clay to make our pots."* Between 1929 and 1949, Nemadji Indian Pottery was made from clays dug at Nemadji Township and Wrenshall.

From 1949 to 1973, most of the pottery was produced using the lighter clay that was taken from the Wrenshall area near Duluth.

Pottery & Tile Plants Sold
In 1969, Dorothy's father Walt passed away and the tile plant was purchased by her husband, Harold and John Mohelski.

Dorothy and Harold continued their sole ownership of the pottery. A few years later the Wahlstroms sold their interest in the operation to Mohelski and Joe D'Antoni of Mankato, Minnesota.

When asked if they had any regrets about selling, Harold said he often thought about starting it up again.

"If I did, I would do it the old way. Make the pottery crude. The new stuff looks perfect ... too manufactured. But then again, I suppose nobody would want the old pottery now-a-days," he said.

D & H Ceramics
After they sold, the Wahlstroms started a business called D & H Ceramics, a wholesale operation in Duluth.

The Wahlstroms' primary customers for greenware and unpainted bisque statuary included school art classes and therapy programs in prisons and nursing homes as well as the hobbyist.

In 2003, 78 year old Harold was still mixing clays and pouring slip into molds.

Dorothy was also teaching a variety of classes in their shop, including china painting and hand-painted ceramic doll making. 🫎

1971-1980

In July of 1971 the majority ownership of the Nemadji Tile and Pottery Company went to Joe D'Antoni.

D'Antoni owned a tile store in Mankato, Minnesota. The purchase of the Moose Lake plant ensured him a steady supply of Nemadji tile for his store and allowed him to sell wholesale to other dealers.

In 1972, D'Antoni and John Mohelski bought the old Kettle River Creamery and made plans to move the tile and pottery operation out of Moose Lake.

This is a newspaper account of the move, published by the *Moose Lake Star-Gazette* on Jan. 25, 1973.

Nemadji Tile Moves to Kettle River

The Nemadji Tile and Pottery Company that has been located in Moose Lake since the mid-twenties, is now in the process of being moved to its new location in Kettle River. Johnny Mohelski of Moose Lake and Joe D'Antoni of Mankato are co-owners.

The enterprise is now located in the former Co-op Creamery building in Kettle River that was vacated about seven years ago (in 1966) when the creamery closed its doors and went out of business.

The reason for the move, said Mohelski, was because the plant facility suited the needs of the pottery company without too much remodeling or additional building. He said they have been moving for the past six months but still must bring the tile back to the original site for burning in the kilns. He said they have purchased some semi-automatic tile making equipment that is much more efficient than the old style handmade process. The company employs four persons and during the busy periods, employs up to eight persons.

The tile is in use in almost every state of the union, in foreign countries, Jamaica and other distant places. Much of the pottery is sold in western states and is known as Badlands Indian Pottery. The tile is used for floors, wainscoting, in bathrooms and for fireplace hearths. Many local homes and businesses use the local product.

The building at Kettle River that was vacated about seven years ago (1966) was the former Cooperative Creamery building that employed

continued on the next page

continued from the previous page

between twenty and twenty-five persons. According to Kettle River Mayor, Ludwig Anderson, the reason the business was discontinued was due to state regulations that eliminated the small milk producers, plus a disagreement with the union on the wage scale that proved to be a contributing factor. When the creamery closed its doors, the small area farmer had no market for his milk. In order to ship milk, the farmer was ordered to invest from one thousand to three thousand dollars in improvements in order to meet the state requirements.

A group, known as the Kettle River Builders, has for the past seven years, endeavored to locate another business in place of the creamery to make up for the business and wage loss suffered in the area when the creamery closed. Two firms, a milk vending machine company and a wood processing firm, indicated interest in locating there but did not follow through as was anticipated.

The Nemadji Tile and Pottery Company, given the name because it was first manufactured by Frank Johnson (father of Mrs. Fred Berquist) in the Nemadji area east of town, and later co-owned by C.J. Dodge, expect to expand its production in the new facility as a result of improved working conditions and equipment. ■

The early 1970s were watershed years for the manufacturing process used to make Nemadji Pottery.

D'Antoni and Mohelski modernized their operation and added new pottery designs. They also altered the methods used to produce their pottery.

One of their first steps was to discontinue the use of Nemadji and Wrenshall clays. D'Antoni said the local clays were inconsistent and produced an inferior product.

Instead, he brought in truckloads of less expensive white clays from Iowa and Kentucky.

During the transition, pottery and tile was transported to the old beehive kilns at Moose Lake for firing until the new kilns were set up in Kettle River.

Both dark local clay and white clays from Iowa and Kentucky were used, as was shellac to treat the interiors of the pottery pieces.

Once the transition was complete, the plant began to use a fired clear glaze for the interior of the pots, to make them waterproof. This glaze has a high gloss appearance. The early efforts produced a black "fly-specked" or "oatmeal" effect created by contaminants in the glazing material. Later, the black specks diminished.

D'Antoni also ordered his own rubber stamps to mark his new products.

NEMADJI EARTH POTTERY

Unique, describes Nemadji Earth Pottery. The designs are largely taken from cooking pots and vases used by the Ancient American Indians.

Twenty-five thousand years ago the Glacial Ice age melted and retreated leaving clays of various shades and composition. Nemadji Pottery is hand made from these clays.

The colors of Nemadji Earth Pottery allow no two pieces to be alike. The warm rich hand-painted colors recall the colorful arts of the Redman, whose spirit lives forever.

1980-1995 legend.

Nemadji Indian River Pottery is individually hand made from clay deposits left by 25,000 year old retreating glaciers.

The various pottery styles are beautifully hand painted and fashioned after original pottery pieces used by the Ancient American Indians.

1995 legend.

His stamp marks including, "Nemadji Indian Pottery Native Clay", "Nemadji Indian Pottery Native Clay U.S.A.", and "Nemadji U.S.A. Indian Pottery."

These stamps were used on D'Antoni's transition pieces as well as the remainder of the Wahlstrom pottery found in the stockroom at the old Moose Lake plant.

By the end of 1973, the transformation of Nemadji Pottery was complete and all pieces produced after that year, under the ownership of D'Antoni, were made exclusively with Kentucky clay and fired glazes.

During his ownership of Nemadji Tile and Pottery Company, D'Antoni used variations of the paper legend accredited to C.J. Dodge.

Nemadji Earth Pottery Company

In 1980, D'Antoni sold the Nemadji Tile and Pottery Plant to Ken Kasden, who formed the corporation Nemadji Earth Pottery Company.

During Kasden's first years as owner, he discontinued the tile operation and landfilled the equipment, focusing instead on the white clay, mold-ware Nemadji swirl pottery.

Kasden commissioned Moose Lake artist Cliff Letty to create the ubiquitous Indian head stamp mark for Nemadji pottery, which was used between 1980 and 1995. Letty said he drew his inspiration from the buffalo head nickel.

Indian Head Trademark Stamp

Trademark stamp in hand, Kasden then turned his focus on the

1980-2001 advertising.

production and mass sale of Nemadji Earth Pottery.

Shortly after the Indian head stamp debut, Kasden received a letter from the Minnesota Attorney General's Office asking him to discontinue its use or include a disclaimer the pottery was not made by Indians.

Kasden refused. In his reply to the Attorney General, Kasden said he would stop using his stamp when the non-Native American product, Land O' Lakes Butter, lost its Indian Princess on its label. He also cited the use of the Indian logo for the

This remarkable handmade pottery explores the softer colors in distinctive tones.
- Coral Peach
- Grey Mist
- Mint Green
- Raspberry Frost

Each piece is beautifully handpainted with its own distinguishing features. Traditional and highly contemporary, uniquely beautiful with a refreshing southwest flavor.

AMERICAN CREATIONS

the Southwest has Arrived

1980-2001 advertising.

promotion of non-native Minnetonka Moccasins.

The matter was dropped.

Between 1980 and 2002, Kasden expanded his products to include specialty lines of ceramic mugs, glassware and high glaze pottery.

Kasden said he would stop using his stamp when the non-Native American product, Land O' Lakes Butter, lost its Indian Princess on its label.

97

Forest Impressions

In recent years, one of Ken Kasden's specialty lines created at Kettle River has struck a chord with serious collectors. While he didn't break the mold when creating the Forest Impression Line, he did break with tradition.

In addition to Nemadji swirl painted pottery, he began to produce pottery decorated with the delicate impressions of leaves plucked from hardwood trees found in the forests surrounding Kettle River, Minnesota.

Oak, ash and maple leaves were popular designs.

Kasden came up with the idea for Forest Impressions while in bed one night watching the tree branches move against his window. The shadows or impressions of the branches intrigued him.

A New Line of Pottery

Many long time collectors of Nemadji are still unaware of the connection between Forest Impressions and the more traditional Nemadji Pottery.

I learned of its existence in the mid-1990s when I visited the Moose Lake home of a Nemadji collector. There in a hanging cupboard in her great room was a small collection of high gloss, white/cream glazed pottery.

Each had an impression of a leaf on its side. There were maple, oak, quaking aspen. Some of the impressions were outlined in red or green.

I was impressed by their simplicity and their beauty.

"*Who made this pottery?*" I asked.

"*It's Nemadji,*" the collector said.

Stunned, I studied the pieces and made a note to look into the history of these Nemadji-made pots. Weeks later, I ran into Ken Kasden, the man instrumental in creating the line in 1982.

Kasden claims he came up with the idea for Forest Impressions while in bed one night watching the tree branches move against his window. The shadows or impressions of the branches intrigued him. Could that image be placed onto a piece of pottery, he wondered?

After trial and error he found that it could and a new line of Nemadji Pottery was born.

Field Work

First, workers had to go out and select leaves from area hardwood

Individual leaves were placed onto greenware and then workers used a rolling process to imbed the leaf into the surface of clay ... Various colored glazes were brushed into the impressions ... then a clear glaze was applied...

trees so that their impressions could be embedded into his pottery.

The pots were made with white Kentucky clay poured into many of the same molds used to create traditional Nemadji Pottery.

According to Kasden, individual leaves were placed onto greenware and then workers used a rolling process to imbed the leaf into the surface of clay. The leaf was carefully removed and the area gently mopped down to smooth imperfections without removing the impression.

Various colored glazes were brushed into the impressions, then as a final step before firing, a clear glaze was applied to the inside and the outside of the pot.

As the season changed, workers found they had to travel farther south to gather their leaves. When they nearly reached the state's southern border – Kasden knew he had to find a better source.

Contacting the University of Minnesota, he learned the leaves could be harvested and chemically preserved. This process provided his workers with a year-round supply of various leaves.

Unfortunately, many steps were required to manufacture the Forest Impression line of Nemadji. Financially, the return wasn't as great as other product lines.

Production lasted less than two years. As a result there aren't many pieces out there to collect. Kasden estimates he manufactured approximately 10,000 pieces of Forest Impression pottery. The lamps, ashtrays, pitchers and bowls are just beginning to show up at flea markets and rummage sales.

While Forest Impression pieces are less than 25 years old, when they are found they command a high price.

The End of the Line

In 1995, Kasden renamed his company, "Terra Dyne Industries Incorporated" and made a significant change.

In order to reduce steps in production and the cost to produce his swirl-painted white clay, mold-ware pottery he stopped glazing the interiors of the pots. He said his customers did not object and many approved of this "new improvement."

At the time of this book's writing, the Kettle River, Minnesota, plant held precious little Nemadji ... workers were busy clearing space for a new line of ceramic products.

Indian River Pottery

He also adopted a new stamp mark, "Indian River Pottery", which features a man in a canoe.

In 1998, a short production of red clay, swirl-painted pottery dishes was produced to celebrate Nemadji's 75th anniversary. These square dishes came in three sizes and were marked with a commemorative Arrowhead stamp mark. The smallest dish was packaged with a piece of incense and distributed in a cardboard box. There was also a legend that accompanied these smaller pieces.

Production Ends

Mass production of Nemadji Pottery was suspended in 2001 in Kettle River, Minnesota. The last of the pots were shipped to tourist shops the winter of 2002.

The end came for this magnificent pottery, not because it lacked a following among collectors. Nor did production cease because there were a lack of orders for the small pots that helped feed an ever growing tourist industry.

Kasden simply decided it was time to change directions. At the time of this book's writing, the Kettle River, Minnesota, plant held precious little Nemadji.

Instead, workers were busy clearing space for a new line of ceramic products.

What we have come to know and love as Nemadji Indian Pottery was manufactured in Moose Lake and Kettle River from 1929 to 2002. During those years tens of thousands of pieces were made.

Collector Pieces

Today, pieces turn up thousands of miles away from their place of origin. Some still have their original paper legends tucked inside them.

What we have come to know and love as Nemadji Indian Pottery was manufactured in Moose Lake and Kettle River from 1929 to 2002. During those years tens of thousands of pieces were made.

Hundreds if not thousands of people are now avidly seeking them at garage sales, antique malls and auction houses.

If you are among these " 'Madji-heads", it is my greatest wish that this book has helped you in your quest to understand the Myth and Magic of Nemadji "Indian" Pottery.

NEMADJI INDIAN POTTERY

Nemadji pottery is individually hand made using colorful clays left by retreating glaciers that once covered the Arrowhead Region. This primative pottery is fashioned after pieces made centuries ago by the first inhabitants of this great region.

Nemadji... is but a small token made to honor the Great Spirit that is said to still dwell in this land, rich in natural resources.

1923-1998

1998 special anniversary legend.

Nemadji Identification

1929-1933 Earliest Stamps

Colored clays. Hand-thrown and mold-ware. Shellac interiors.

#202

POTTERY

1933-1948 Pre- and Post-WWII

Colored clays. Mold-ware. Shellac interiors.

Handmade
Nemadji Indian Pottery
(From Native Clay)

NEMADJI BADLANDS POTTERY
CONTAINS
BADLANDS
CLAY

NORTH DAKOTA
CONTAINS
BADLANDS
CLAY
BADLANDS POTTERY

NO.DAK. BADLANDS POTTERY
CONTAINS
BADLANDS
CLAY

NEMADJI
BLACKHILLS
POTTERY

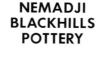

WALKER, MINN.

POTTERY

NEMADJI BADLANDS POTTERY

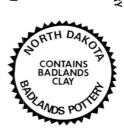

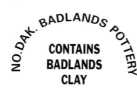

Blank or
Town Name Here

POTTERY

1949-1973

Color clays. Mold-ware. Shellac interiors.

NEMADJI

**NEMADJI
POTTERY**

**NEMADJI
POTTERY**

1973-1980

Colored or white clays. Mold-ware. Shellac or clear fired glaze interiors.

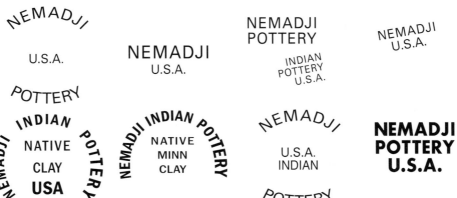

NEMADJI
U.S.A.
POTTERY

NEMADJI
U.S.A.

NEMADJI
POTTERY
INDIAN
POTTERY
U.S.A.

NEMADJI
U.S.A.

NEMADJI INDIAN POTTERY
NATIVE
CLAY
USA

NEMADJI INDIAN POTTERY
NATIVE
MINN
CLAY

NEMADJI
U.S.A.
INDIAN
POTTERY

NEMADJI
POTTERY
U.S.A.

1980-2002

White clay. Mold-ware. Clear fired glaze or non-treated interiors.

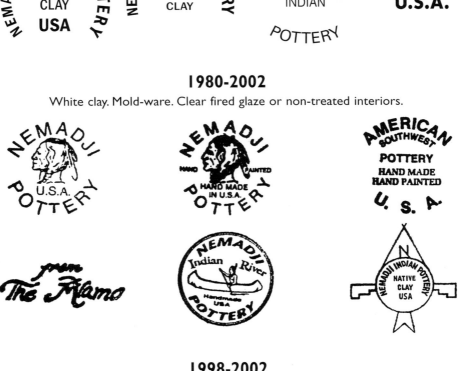

NEMADJI
U.S.A.
POTTERY

NEMADJI
HAND PAINTED
HAND MADE
IN U.S.A.
POTTERY

AMERICAN
SOUTHWEST
POTTERY
HAND MADE
HAND PAINTED
U. S. A.

from The Alamo

NEMADJI
Indian River
Handmade
USA
POTTERY

NEMADJI INDIAN POTTERY
NATIVE
CLAY
USA

1998-2002

75th Anniversary commemorative. Non-treated interiors.

NEMADJI TILE & POTTERY CO.
MOOSE LAKE, MINN.

Garden of the Gods Stamps

1932-1940

Colored clays. Hand-thrown and mold-ware. Shellac interiors.

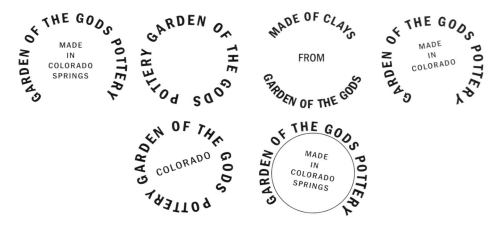

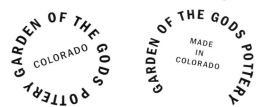

1945-1982

White clays. Mold-ware. Shellac or clear fired glaze interiors.

White clays. Mold-ware. Green fired glaze interiors.

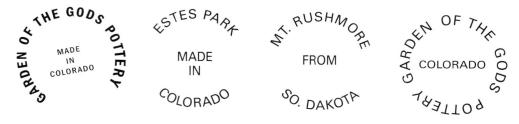

When it comes to dating your Nemadji, the marks on the preceding pages will put you in the right ball park.

STAMP MARKS

These marks are either computer generated recreations or actual stamp impressions used to mark pottery in my personal collection.

These by no means represent all stamps used during the 75-plus years Nemadji was produced in Minnesota. Estimates indicate there maybe at least 10 more stamps yet to be copied and categorized.

During interviews with prior owners of the pottery operation, it became evident that individual shops bought unmarked pottery and applied their own stamps.

We also learned that in the 1990s the "Indian head" and the "Man in Canoe" stamps were kept in the same drawer. Rushed for time or filling a special request, the person responsible for shipping orders often grabbed the older Indian Head stamp and applied it to new pottery. It's possible this also happened during earlier production in Moose Lake.

Hitting a home run will require that you determine two other factors: the clay color and interior treatment of your pot.

CLAY COLOR

1929-1973 is identified by its dark red-brown, light red-brown, buff-butterscotch, or light yellow or light green clay bodies. Nemadji and Wrenshall clays were used to make these pots. The end color depended on which clay was on hand during the pouring process.

According to Eric Hellman, each firing also created unique chemical reactions within clay which could determine the color of pottery.

These reactions could not be controlled and added to the unique quality of Nemadji Pottery.

*1973-2002** is identified by its white Iowa and Kentucky clay bodies. Pots produced right after the move to Kettle River came out of the kiln the color of dried gray cement or oatmeal, off white with small specks of black.

Eventually workers improved their technique using the new clay and glazing techniques and this speckling effect was reduced.

*NOTE: both colored and white clays were used from 1970-1973 during the move from Moose Lake and the start-up and modernization of the new plant in Kettle River. It took a while for the stores of regional clays to be exhausted. But by 1973, white Kentucky clay was used exclusively to make the pottery.

Now that you have identified your stamp and determined the color of clay used to make your pot, just one step remains.

INTERIOR TREATMENT

The interiors of the pottery made between 1929 and 1973 were treated with a simple and effective shellac wash. Workers poured shellac into the pot, swished it around, then poured it back into the shellac container. Paint brushes were used to finish the larger pieces.

Over time this shellac developed a patina that today gives off either a rich reddish brown, or yellow orange tint. The darkness of the patina depends on the number of times the shellac was recycled.

In 1972, in an effort to modernize, Nemadji producers began to experiment with fired-on glazes to treat the interiors of their pottery. The clear glaze sealed the pots and made them watertight. By 1973, all Nemadji received this interior clear glaze treatment. This treatment was discontinued in the mid 1990s. In an effort to save money, all interior treatment was stopped. Pottery produced after 1995 have untreated bisque interiors.

POTTERY PRICING

All prices are for fine condition. No chips or cracks. Blemishes in the paint, a minute flaking of the shellac and rough seams add character and do not lower value. Prices are determined by demand. While they may be lower at garage sales and auctions in Northern Minnesota, they are often higher on the East and West Coasts.

Prior to publishing this book, a small red clay pot from the 1940s would sell in the Moose Lake, Minnesota area for $10. That same pot in an antiques mall in California or Illinois would sell for $45.

Another factor in determining prices is the number of individual styles and sizes produced. More small pots were made because they were easily carried by tourists. The larger pots were difficult to stow and may have been broken on the long trip home.

Sale price can also be impacted by the personal taste of the collector. One group of collectors will only collect early, red clay pots with primary color paints. Others might collect Forest Impressions exclusively.

There are also those who will pay whatever it takes to make the right pot, with the right swirl design a part of their collection. An example of this phenomenon was found on the internet recently. A small red pot sporting a "swirl" in the shape of a feather sold for $55.

A fair appraisal of Nemadji's value can be difficult and confusing, but the development of the Internet has helped to make that task a lot easier.

Internet sales have provided a rich trove of new and old Nemadji pottery pieces and have helped to bring balance to their price. Combining all the factors outlined above, I have compiled the following list of values.

Nemadji Value Guide

PLATE I
Nemadji 1933-1972
QUICK REFERENCE

Nemadji Pottery Catalog, circa 1960s, use for quick price reference for mold-ware pottery produced in Moose Lake, between 1933 and 1972, utilizing **Nemadji and Wrenshall colored clays.** Shellac interior treatment

NOTE: Handmade pots with Arrowhead mark are higher in value.

STYLE	HEIGHT	VALUE
#161	8"	$125-$150

PLATE 2
QUICK REFERENCE
continues

L to R

TOP TO BOTTOM

STYLE	HEIGHT	VALUE
#127	4"	$75-90
#139	6 1/5"	$75-90
#118	4 3/4"	$75-90
#105	4"	$75-90
#107	5"	$75-90
#119	6"	$75-90
#185	5" 3/4"	$75-90
#136	3"	$75-90
#116	4 1/5"	$55-60
#123	4 1/2"	$75-90
#124	5"	$75-90
#125	2 1/4"	$50-55
#126	3 3/4"	$50-55
#187	2 1/2"	$50-55
#201	3 1/10"	$45-50
#202	3 1/4"	$45-50
#204	3 1/4"	$45-50
#205	2 1/2"	$50-55
#128	2"	$45-50
#160	2 1/2"	$45-50
#206	4"	$50-65

PLATE 3
QUICK REFERENCE
continues

Nemadji Pottery Catalog, circa 1972, during transition phase, use for quick price reference for mold-ware pottery produced at Moose Lake, between 1969 and 1972, utilizing Nemadji and Wrenshall colored clays. Shellac interiors.

NOTE: Handmade pots with Arrowhead mark are higher in value.

NOTE: Number changes for earlier styles.

The following styles have been added

STYLE	HEIGHT	VALUE
#105	2 1/2"	$45-50
#305	4 3/4"	$75-90
#401	2"	$75-90
#402	8 1/4"	$75-90
#404	7 1/4"	$75-90

PLATE 4
QUICK REFERENCE
continues

Nemadji Pottery Catalog, circa 1973.

The following styles have been added

STYLE	HEIGHT	VALUE
#601	14"	$125-150
#502	12"	$80-90

PLATE 5
QUICK REFERENCE
continues

Nemadji Pottery Catalog, NOTE: Return of teepee The following styles have been added

STYLE	HEIGHT	VALUE
#206	4"	$45-50
#407	6"	$75-90

PLATE 6
Nemadji 1990s
Feather Lite Earrings

White clay, non-glazed

11 styles	$10-15 pr.

PLATE 7
Earliest Nemadji Pottery 1929-1931

Nemadji clay, shellac interiors. Arrowhead mark

STYLE	HEIGHT	VALUE
#127	4"	$125-130

DESCRIPTION: Cream buff to lt. butterscotch clay color. Red/yellow/black/blue paint. Mold-ware.

STYLE	HEIGHT	VALUE
#124	4 3/4"	$125

DESCRIPTION: Cream buff to lt. butterscotch clay color. Blue/yellow/orange/cream/brown paint. Mold-ware.

STYLE	HEIGHT	VALUE
#126	3 3/4"	$95

DESCRIPTION: Lt. brown clay. Red/yellow/black/blue paint. Mold-ware.

STYLE	HEIGHT	VALUE
#126	2 3/4"	$95

DESCRIPTION: Cream buff clay. Blue/yellow/black/orange paint. Hand-thrown.

STYLE	HEIGHT	VALUE
#116	4"	$150/pr

DESCRIPTION: Cream buff to lt. butterscotch clay. Blue/yellow/orange/cream/brown paint. Mold-ware.

PLATE 8
Earliest Nemadji Pottery continues, 1929-1931
Nemadji clay, shellac interiors. Arrowhead mark and unmarked.

STYLE	HEIGHT	VALUE
#124	5"	$90

DESCRIPTION: Buff to butterscotch clay. Red/blue/black/yellow paint. Mold-ware (unmarked).

| #126 | 4" | $95-100 |

DESCRIPTION: Cream buff clay. Blue/orange/black/yellow paint. Mold-ware (Arrowhead mark).

| #203 | 3" | $85 |

DESCRIPTION: Cream buff to lt. yellow clay. Red/blue/yellow/black paint. Mold-ware (Arrowhead mark).

| #160 | 2 3/4" | $55-60 |

DESCRIPTION: Cream clay. Orange/blue/yellow/black paint. Hand-thrown (Arrowhead mark).

| Candlestick 7 1/4" | | $100 |

DESCRIPTION: Lt. Brown clay. Blue/yellow/red/black paint. Mold-ware (unmarked).

| #126 | 3 1/2" | $95-100 |

DESCRIPTION: Cream buff clay. Orange/black/yellow/blue paint. Hand-thrown (Arrowhead mark).

PLATE 9
Garden of the Gods 1932-1940
GOG mark

STYLE	HEIGHT	VALUE
Jug	3 1/4"	$55

DESCRIPTION: Cream buff clay. Blue/red/yellow/black paint. Hand-thrown/shellac.

| Pitcher | 4" | $75-85 |

DESCRIPTION: Buff clay. Blue/red/yellow/black paint. Hand-thrown/glaze.

| Sugar bowl 2 1/4" | | $40-50 |

DESCRIPTION: Cream buff to lt. pink clay. Orange/yellow/blue/black paint. Hand-thrown/shellac.

| Jug | 2 3/4" | $45-55 |

DESCRIPTION: Cream buff clay. Blue/red/yellow/black paint. Hand-thrown/shellac.

| Cup & Saucer 3/4" | | $35 |

DESCRIPTION: Cream buff clay, red/yellow/blue paint. Hand-thrown/shellac.

| Creamer 2 1/2" | | $40-50 |

DESCRIPTION: Buff to lt. pink clay. Orange/yellow/blue/black paint. Hand-thrown/shellac.

PLATE 10
Garden of the Gods continues, 1932-1940
GOG mark

STYLE	HEIGHT	VALUE
Shoulder Vase 3 3/4"		$75-85

DESCRIPTION: Buff clay. Blue/red/yellow/black paint. Hand-thrown/ shellac.

| Gooseneck 5" | | $60-70 |

DESCRIPTION: Buff clay, Blue/red/yellow/black paint. Hand-thrown/shellac.

| Bowl | 4 1/4" wide | $55-65 |

DESCRIPTION: Buff clay. Blue/orange/yellow/black paint. Hand-thrown/shellac.

| Ovoid vase 3" | | $45-55 |

DESCRIPTION: Buff to lt. yellow clay. Blue/red/yellow/black paint. Mold-ware/shellac.

| Ovoid vase 2 1/2" | | $55-65 |

DESCRIPTION: Buff clay. Blue/red/yellow/black paint. Hand-thrown/untreated

| Vase | 1 1/2" | $55-65 |

DESCRIPTION: Buff clay. Blue/red/yellow/black paint. Signed: Pikes Peak Alt. 14,110. Hand-thrown/untreated

| Large bowl with frog | 5 1/2" wide | $75-85 |

DESCRIPTION: Buff to lt. pink clay. Blue/orange/yellow/black paint. Mold-ware/shellac.

PLATE 11
Garden of the Gods continues, 1945-1982
GOG mark. White clay

STYLE	HEIGHT	VALUE
Candlesticks	3"	$75 pr.

DESCRIPTION: Red/blue/yellow paint. Mold-ware/non-treated.

| Large Vase | 7" | $45 |

DESCRIPTION: Blue/red/green paint. Mold-ware/green glaze.

| Bud vases | 5" | $30/each |

DESCRIPTION: Red/blue/yellow/black paint. Mold-ware/shellac.

| Bowl | 3 1/2" | $55-65 |

DESCRIPTION: Red/blue/yellow paint. Hand-thrown, clear glaze.

PLATE 12
Garden of the Gods continues, 1970-1982
DESCRIPTION: White clay, green/brown/cream paint. Mold-ware, green glaze interiors.

STYLE	HEIGHT	VALUE
Bowl with frog		
	2¹/₂" x 6¹/₄"	$35

Black Hills South Dakota mark.

Vase	7 ¹/₂"	$75

Mt. Rushmore So. Dakota mark.

Cup	2"	$15

Garden of the Gods Pottery mark.

Jug	3 ¹/₄"	$25

Estes Park Colorado mark.

Bowl	2¹/₂" x 4¹/₄"	$20

Garden of the Gods Pottery mark.

PLATE 13
Nemadji - 1935-1947
J. Edwin Dodge: experimental pieces. Hand-incised with dates and initials.

STYLE	HEIGHT	VALUE
Bowl	6" wide	$100

DESCRIPTION: Cream buff to lt. yellow clay. Brown/blue/yellow/orange paint. Mold-ware/clear glaze.

#202	3 ¹/₄"	$40

DESCRIPTION: Cream buff to lt. yellow clay. Brown/blue/yellow/orange paint. Mold-ware/shellac.

Jug	5"	$200

DESCRIPTION: Brown clay. Brown/blue/yellow/black paint. Hand-thrown/shellac.

Vases various	2¹/₂"-3"	$75-100ea.

DESCRIPTION: Blue, white and black clays. Hand-thrown/clear glaze interiors.

PLATE 14
Nemadji advertising photo Circa 1950-1960
DESCRIPTION: Cream buff to lt. brown clay. Red/black/blue/cream paint. Mold-ware, shellac interiors (clockwise).

STYLE	HEIGHT	VALUE
#139	6 ¹/₅"	$75-90
#107	5"	$75-90
#204	3 ¹/₄"	$45-50
#123	4 ¹/₂"	$75-90
#185	5 ³/₄"	$75-90
#136	3"	$75-90
#187	2 ¹/₂"	$50-55

PLATE 15
Nemadji advertising photo Circa 1950
DESCRIPTION: Lt. brown clay. Red/black/blue paint. Mold-ware, shellac interiors.

STYLE	HEIGHT	VALUE
#118	4 ³/₄"	$75-90
#123	4 ¹/₂"	$75-90

PLATE 16
Nemadji - 1946-1947
Factory seconds collected by worker.

DESCRIPTION: Red to lt. brown clay. Black/red/cream/yellow paint. Mold-ware, shellac (unmarked).

STYLE	HEIGHT	VALUE
#123	4 ¹/₂"	$75-90
#116	4"	$55-60
#119	6"	$75-90

PLATE 17
Nemadji - 1935-1949
Mold-ware, shellac

STYLE	HEIGHT	VALUE
#139	6"	$75-90

DESCRIPTION: Red clay. Red/black/orange paint (Black Hills mark).

#126	3 ³/₄"	$50-55

DESCRIPTION: Red clay. Red/blue/cream/black paint (Badlands mark).

#107	5 ¹/₂"	$75-90

DESCRIPTION: Red clay. Red/black/orange paint (Badlands mark).

#187	2 ¹/₂"	$50-55

DESCRIPTION: Red clay. Red/black/orange paint (Black Hills mark).

#127	3 ³/₄"	$75-90

DESCRIPTION: Red clay. Blue/brown/cream/black/orange paint (Black Hills mark).

PLATE 18
Nemadji - 1933-1949
Mold-ware, shellac interiors (Badlands mark).

STYLE	HEIGHT	VALUE
#185	5¹/₂"	$75-90

DESCRIPTION: Red clay. Blue-green/brown/black/orange paint.

#119	6"	$75-90

DESCRIPTION: Cream buff to lt. yellow clay. Black/orange/brown/blue paint.

#118	4 ¹/₂"	$75-90

DESCRIPTION: Red clay. Blue-green/red/black/cream paint.

#116	4"	$150/Pr.

DESCRIPTION: Cream buff to pink clay. Blue/red/black paint.

#124	4 ¹/₂"	$75-90

DESCRIPTION: Cream buff to lt. yellow clay. Red/blue/brown/black paint.

#202	3"	$45-50

DESCRIPTION: Red clay, green-blue/black/red/yellow paint

#122	5 ¹/₂"	$95

DESCRIPTION: Cream buff to pink clay. Brown/orange/blue/yellow paint.

PLATE 19
Nemadji - 1933-1949
Mold-ware, shellac interiors (North Dakota marks).

STYLE	HEIGHT	VALUE
#202	3 1/4"	$45-50

DESCRIPTION: Cream buff to pink clay, blue-green/brown/cream/orange paint.

#203 3" $85
DESCRIPTION: Cream buff to pink clay. Blue-green/red/black/ yellow paint.

#116 4" $55-60
DESCRIPTION: Red clay. Blue-green/red/yellow/black paint.

#201 3" $45-50
DESCRIPTION: Cream buff to pink clay. Yellow/red/blue/black paint.

#202 3 1/4" $45-50
DESCRIPTION: Cream buff to pink clay. Blue-green/brown/cream/orange paint.

#107 5" $75-90
DESCRIPTION: Red clay. Blue/yellow/brown/orange paint.

#119 6" $75-90
DESCRIPTION: Cream buff to pink clay. Green-blue, black, red, yellow paint.

#118 5" $75-90
DESCRIPTION: Cream buff to pink clay. Blue/orange/brown/yellow paint.

PLATE 20
Nemadji - 1933-1948
Red clay, mold-ware, shellac interiors (handmade Nemadji Indian Pottery "from native clay" mark).

STYLE	HEIGHT	VALUE
#136	3"	$75-90

DESCRIPTION: Brown/black/orange/blue-green/cream paint.

#124 4 1/2" $75-90
DESCRIPTION: brown/blue-green/black/orange paint.

#160 2 1/2" $45-50
DESCRIPTION: Brown/black/orange/blue-green/cream paint.

#202 3" $45-50
DESCRIPTION: Brown/black/orange/blue-green/cream paint.

#204 3 1/4" $45-50
DESCRIPTION: Brown/black/orange/blue-green/cream paint.

#119 6" $75-90
DESCRIPTION: Orange/black/cream/blue-green paint.

#161 8" $125-150
DESCRIPTION: Orange/black/cream/blue-green paint.

#123 4 1/2" $75-90
DESCRIPTION: Black/orange/cream/blue-green paint.

PLATE 21
Nemadji - 1933-1969
Mold-ware, shellac interiors (Nemadji Pottery mark).

STYLE	HEIGHT	VALUE
#123	4 1/2"	$75-90

DESCRIPTION: Buff clay. Red/black/blue-green/yellow paint.

#107 5" $75-90
DESCRIPTION: Cream-buff clay. Red/black/yellow/blue-green paint.

#105 4" $75-90
DESCRIPTION: Buff clay. Red/black/blue/yellow paint.

#204 3 1/4" $45-50
DESCRIPTION: Buff to lt. yellow clay. Red/black/blue/yellow paint.

#125 2 1/4" $50-55
DESCRIPTION: Buff to lt.yellow clay. Red/black/blue/yellow paint.

#201 3 1/10" $45-50
DESCRIPTION: Buff clay. Red/black/green paint.

#127 4" $75-90
DESCRIPTION: Cream-buff clay. Red/black/yellow/blue-green paint.

PLATE 22
Nemadji - 1949-1969
Buff-pink to light yellow clay. Dorothy's Red order: Red/green/black/cream or ivory paint. Mold-ware, shellac interiors (Nemadji Pottery mark).

STYLE	HEIGHT	VALUE
#204	3 1/4"	$45-50
#161	8"	$125-150
#127	4"	$75-90
#205	2 1/2"	$50-55
#201	3"	$45-50
#128	2"	$45-50

PLATE 23
Nemadji - 1949-1969
Buff-pink to light yellow clay. Dorothy's Brown order: Brown/green/orange/black/blue paint. Mold-ware, shellac interiors (Nemadji Pottery mark).

STYLE	HEIGHT	VALUE
#185	5 3/4"	$75-90
#161	8"	$125-150
#123	4 1/2"	$75-90
#139	6 1/5"	$75-90
#160	2 1/2"	$45-50
#127	4"	$75-90
#128	2"	$45-50
#127	4"	$75-90
#203	3"	$50-55

PLATE 24
Nemadji - 1982-1983
Forest Impressions
White clay, fired clear glaze inside and out. Mold-ware (Indian head mark).

STYLE	HEIGHT	VALUE
E-2	7 1/2"	$200-225
D-3	8 3/4"	$125-150
D-6	5"	$125-150
C-3	7 1/2" wide	$75-90

PLATE 25
Nemadji - 1982-1983
Nemadji Forest Impressions
White clay, fired clear glaze
Mold-ware (Indian Head
mark).

STYLE	HEIGHT	VALUE
F-1	15"w/globe	$250-275
Electric lamp	16"base	$350
D-2	6 ³/₄"	$125-150
E-1	8 ¹/₂"	$250-300

(incised presentation piece)

PLATE 26
Nemadji - 1973-1980
White clay, glaze interior.
Mold-ware.

Bird feeder	$35

PLATE 27
Nemadji - 1973-1980
End-of-days
White clay, fired clear glaze
interiors. Mold-ware, with
hand applied features
(variety of marks).

STYLE	HEIGHT	VALUE
Double Handle Vase	8"	$75-100
Oblong Vase	3 ¹/₂"	$100
Nut Cups 1 ¹/₂" (Harvey Myre)		$15 each
Birdfeeder 9 ¹/₂" (Alvin Siltenen)		$80-90
Pitcher 6 ¹/₂" (H.M.)		$100-125

PLATE 28
Nemadji - 1973-1980
White clay, fired clear glaze
interiors. Mold-ware (variety
of U.S.A. marks).

STYLE	HEIGHT	VALUE
Bean Pot with lid	8 ¹/₂"	$100-125
Electric Lamp	9 ¹/₂"	$45-50
Beehive Vase	8"	$45-50
Planter	11 ¹/₂"	$100-125

PLATE 29
Nemadji - 1973-1990
Experimental
White clay, fired interior and
exterior glazes. Mold-ware.

STYLE	HEIGHT	VALUE
Vase incised decoration	8"	$75-90
Pitcher	7 ¹/₂"	$50-60
Beehive Vase	6"	$50-60
Vase with glaze swirls (H.M.)	14"	$150-175

PLATE 30
Nemadji - 1933-1995
Color and white clays.
Shellac and glaze interiors.
Mold-ware.

STYLE	HEIGHT	VALUE
#139	6 ¹/₅"	$75-90

Red clay. Shellac, brown,
green, black, orange and
cream paint. (Nemadji Indian
Pottery "native clay" mark).

#118	4 ³/₄"	$75-90

Red clay. Shellac, black, blue,
orange, yellow paint
(unmarked).

#136	3"	$75-90

Red clay, shellac, black, blue-
green, red, yellow paint
(unmarked).

#128	2"	$45-50

Cream-buff clay. Black,
yellow, blue paint (Nemadji
Pottery mark).

#206	4"	
Ashtray	³/₄"	$100-125 set

Cream-buff clay. Non-treated,
black, red, orange paint
(Nemadji Indian Pottery
native clay U.S.A. mark).

#127	4"	$75-90

Red clay. Shellac, black, blue-
green, red, yellow paint
(Nemadji Pottery mark).
Aveda® special order

Stones	$5 each

Red clay. Non-treated.

PLATE 31
Nemadji - 1998
75th Anniversary dishes
Red clay. Non-glazed
(commemorative Arrowhead
mark or incised with Indian
head mark).

6" x 6"	$45-60
8 ¹/₂" x 8 ¹/₂"	$70-85
2 ¹/₂" x 2 ¹/₂" in box	$35-40

PLATE 32
Nemadji - 1990-95
Feather Lite earrings.
White clay, non-glaze, Multi-
color paint.

Earrings on card	
1"-1 ¹/₄"	$10-15/pr.

PLATE 33
Nemadji - 1982-83
Cowboy and Indian
caricature mugs.
White clay, mold-ware with
hand applied features. Clear
glaze interiors and exteriors.
Designed by Cliff Letty
(signed).

STYLE	HEIGHT	VALUE
Indian	4"	$50
Cowboy	4"	$50

PLATE 34
Nemadji - 1990s
Aveda® promotion
Red clay, glazed.

Oblong incense burner	$10
Boxed set with gravel for fragrant oils	$15
Light bulb ring for oils	$5

PLATE 35
Nemadji - 1995-2002
T-Lite Lanterns
White clay, various paint colors. Mold-ware.

STYLE	HEIGHT	VALUE
Taper holders		$10
Light house	6 ¹/₂"	$30
Saloon	4"	$25
Adobe	3 ³/₄"	$15
Cactus	5"	$20
Mushroom	3 ¹/₂"	$25
Cantina	5"	$25
Small lighthouse	6"	$30

PLATE 36
Nemadji - 1973-1995
Earth Pottery
White clay, multi-color paint Mold-ware, clear glaze interiors (native clay, U.S.A. and Indian Head marks).

SERIES	HEIGHT	VALUE
#000	2"	$10 ea.
		$50/set 4
#100	2¹/₄"-3¹/₄"	$15-18
#200	3"-5"	$20-22

PLATE 37
Nemadji
Earth Pottery continues

SERIES	HEIGHT	VALUE
#300	4"-6 ¹/₄"	$25-28
#307	4"-7"	$30-35
#308	3¹/₄"-4¹/₄"	$10-15

PLATE #38
Nemadji
Earth Pottery continues

SERIES	HEIGHT	VALUE
#400	3"-8"	$35-40
#500	5"-10¹/₄"	$40-50
#600	9¹/₂"-12¹/₂"	$90-100
#700	18"	$125

PLATE 39
Nemadji
1995-2002 American Southwest
White clay. Multi-color paint schemes; Teal, Grey mist, Coral peach, Raspberry. Mold-ware, un-treated interiors (Indian Head and Indian-in-canoe marks).

STYLE	HEIGHT	VALUE
TOP ROW:		
#701	18"	$100
#601	14"	$85
MIDDLE ROW:		
#501	7 ³/₄"	$40-45
#502	9 ³/₄"	$40-45
#503	12 ¹/₂"	$40-45.
#504	10 ¹/₂"	$40-45
#505	8 ¹/₂"	$40-45
#506	7"	$40-45
#507	6"	$40-45
BOTTOM ROW:		
#403	6 ³/₄"	$30-35
#405	5 ³/₄"	$30-35
#407	6 ¹/₄"	$30-35
#409 (flat sided)		$30-35
#410		$30-35
#413 (flat sided)		$30-35

PLATE 40
Nemadji
American Southwest continues

STYLE	HEIGHT	VALUE
TOP ROW:		
#301	4"	$20-22
#302	4"	$20-22
#304	3 ³/₄"	$20-22
#311	4 ¹/₂"	$20-22
#312	5 ³/₄"	$20-22
MIDDLE ROW:		
#201	2 ³/₄"	$15-18
#202	4 ¹/₂"	$15-18
#203	4"	$15-18
#206	4"	$15-18
#207	4"	$15-18
#208	3 ³/₄"	$15-18

BOTTOM ROW:		
#102	3 ¹/₂"	$10-12
#103	3	$10-12
#105	4 ¹/₂"	$10-12
#106	4"	$10-12
#107	2 ¹/₄"	$10-12

PLATE 41
Nemadji
1982-83 Forest Impressions
White clay, fired, clear glaze exteriors and interiors. Mold-ware with hand applied decoration (Indian Head mark).

STYLE	HEIGHT	VALUE
F-2	15"	$250-275
A-2	3 ¹/₄"	$50
E-2	7 ¹/₂"	$200-225
D-2	6 ³/₄"	$125-150
C-2	4 ¹/₂"	$75-90

PLATE 42
Nemadji
Forest Impressions (continues)

STYLE	HEIGHT	VALUE
A-1	5"-7"wide	$50
A-2	3 ¹/₄"	$50
B-1	4 ¹/₂"	$60

PLATE 43
Nemadji
Forest Impressions continues

STYLE	HEIGHT	VALUE
C-1	8 ¹/₂"	$75-90
C-2	4 ¹/₂"	$75-90
C-3	7 ¹/₂"wide	$75-90
C-4	6"	$75-90
D-1	8 ¹/₂"	$125-150
D-2	6 ³/₄"	$125-150
D-3	8 ³/₄"	$125-150
D-4	7 ¹/₂"	$125-150
D-5	7"	$125-150
D-6	5"	$125-150

PLATE 44
Nemadji
Forest Impressions
continues

STYLE	HEIGHT	VALUE
E-1	8 ½"	$200-225
E-2	7 ½"	$200-225
F-1	15"	$250-275
F-2	15"	$250-275

PLATE 45
Nemadji - 1992
Specialty line "Nostalgic
Memories" mug collection

Cup	$10
Set of four	$75

PLATE 46
Nemadji - 1986
Specialty line
"The Great Outdoors"
wildlife mug collection
11 oz. Ceramic coffee mug

Cup	$10
Set of four	$75

HUNTERS' MUG SERIES:
Ducks, geese, pheasant,
deer artwork.

FISHERMEN'S MUG SERIES:
Bass, trout, walleye, musky
artwork.

References

Legends
"Lorelei" Encyclopedia Mythica
http://www.pantheon.org

Newspapers
Arrowhead Leader, Moose Lake, MN; Nov. 12, 1985

Star Gazette, Moose Lake, MN; May 21, 1942; May 28, 1942; Oct. 1948; Jan. 25, 1973.

Star Gazette-Family Journal, Moose Lake, MN; June 1949.

Television
WDSE Television, Duluth, MN; Oct. 15, 1967 Maxim, Glen.

Maps, Books and Pamphlets
Antiques Journal, August 1973.

Anderson, David E.; *Moose Lake Area History,* Moose Lake Historical Society, 1965.

Carlton, Carol and Jim; *Collector's Encyclopedia of Colorado Pottery Identification and Values,* Collector Books a division of Schroeder Publishing Co., Inc. Paducah, Kentucky, 1994.

Carlton County Fair Official Premium List, Carlton County Fair Board 1996.

Carroll, Francis M. and Raiter, Franklin R.; *The Fires of Autumn The Cloquet-Moose Lake Disaster of 1918,* Minnesota Historical Society Press, St. Paul, 1990.

Carroll, Francis M. and Wisuri, Marlene; *Reflections of our Past: Pictoral History of Carlton County, Minnesota,* Carlton County Historical Society, Carlton and Donning Company Publishers, Virginia Beach, VA, 1997.

Gifford, David Edwin; *Collector's Encyclopedia of Niloak,* Collectors Books, Paducah, Kentucky, 1993.

Gillmer, Susan; past president and general manager of Red Wing Pottery Sales, Inc. Author of *The history of Red Wing Pottery* as published on the Redwing Collectors Website located at www.redwingcollectors.org/History.htm.

Kovel, Ralph and Terry; *Kovel's American Art Pottery The Collectors guide to makers, marks, and factory histories.* Crown Publishers, Inc. New York, 1993.

Manni, Edwin E.; *Comp. Kettle River, Automba, Kalevala and Surrounding Area: History, Stories;* also *1918 Forest Fire,* 1978.

Sasicki, Richard and Fania, Josi; *Collector's Encyclopedia of Van Briggle Art Pottery an Identification and Value Guide,* Collector Books, a division of Schroeder Publishing Co., Inc. Paducah, Kentucky, 1994.

Upham, Warren, *Minnesota Geographic Names, Edition ed.:* Minnesota Historical Society, reprinted 1969.

Internet Resources

Co-trading-post.com
 -Garden of the Gods Trading Post.

Computerpro.com/~nemadji
 -Nemadji Collectors Club.

redwingcollectors.org
 -Redwing Pottery Collector's Club.

wisconsinpottery.org
 -Wisconsin Pottery Association.

Interviews and correspondence*

Ballou, Howard (the late); Nemadji Town Historian (interview conducted 1995).

Berquist, Frances (Johnson); father Frank Johnson founded Northern Brick Company (interview conducted 1997).

Berquist, Lloyd; son of Frances (1997 correspondence).

Bogenholm, Russ and Gerin, father owned Nemadji Tile Plant in Moose Lake. Both worked in plant (interviews conducted 1996-97-2003).

Carlton, Carol; Author of "The Collectors Encyclopedia of

*All notes, audio tapes and/or transcripts in the possession of the author.

Colorado Pottery Identification and Values" (interview conducted 2003).

D'Antoni(o), Joe; (the late) past owner of Nemadji Tile and Pottery Company in Kettle River (interview conducted 1997).

Dodge family letters written 1928-1938.

Dodge, Stanford; father, C.J. Dodge co-founded Nemadji Tile and Pottery Company in Moose Lake with Frank Johnson (interviews conducted 1995-1996).

Hanson, Skip; (the late) editor *Arrowhead Leader,* Moose Lake (interview conducted 1995).

Kasden, Bruce; former Moose Lake mayor and city counselor, brother of Ken (interview conducted 1995).

Kasden, Ken; owner of Nemadji tile and Pottery in Kettle River (interviews conducted 1995-2002).

Keith, Helen; former employee at Nemadji Tile and Pottery Company in Kettle River (interviews conducted 1995, 1997).

Koivisto, Greg; Artist, former manager Nemadji Tile and Pottery Company in Kettle River (interview conducted 1997).

Larson, Morita (Dodge); daughter of C.J. Dodge Co-founder of Nemadji Tile and Pottery (interviews conducted 1996-97).

Letty, Cliff; artist, former employee Nemadji Tile and Pottery Company in Kettle River (interviews conducted 1996-1997).

Mohelski, John; former co-owner Nemadji Tile and Pottery Company (interview conducted 1997).

Myre, Helen; husband Harvey (the late) worked at Nemadji Tile and Pottery Company in Moose Lake and Kettle River (interviews conducted 1996-1997).

Siltanen, Alvin and Bruce; worked at Nemadji Tile and Pottery Company in Kettle River (interviews conducted 1994, 1995 and 1996).

Wahlstrom, Harold and Dorothy; former owners of the Nemadji Pottery operations in Moose Lake (interviews conducted 1995, 1996, 1997, 1998)

Index

About the author ...

Michelle D. Lee makes her home in Moose Lake, Minnesota the birthplace of Nemadji Indian Pottery. When she isn't traveling the country searching for her favorite pottery she works as a television Journalist in Duluth, Minnesota.

She began her quest to learn about Nemadji Indian Pottery in 1983 when she bought her first piece at a garage sale. Today she admits to owning hundreds more. Michelle says, "Yes, it is an addiction, but a healthy one ... and one shared by a lot of other "Madji-heads."

Notes